IMAGES
of America

UNICOI AND
LIMESTONE COVE

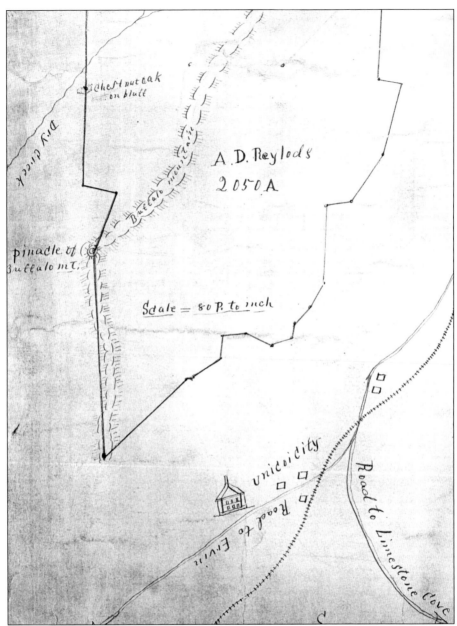

This plat, drawn by surveyor D. J. White in 1900, refers to Unicoi as "Unicoi City." Note the "Pinnacle" of Buffalo Mountain shown northwest of Unicoi and the road to Limestone Cove and Unaka Mountain to the southeast. The railroad track, running to the right of Unicoi, had been in place since 1888. The back of the plat is labeled "Marbleton Farm." (Courtesy of Unicoi County Historical Society.)

ON THE COVER: In the 1940s, Hassie Hopson's family, like many in Unicoi, hauled water from Hoy Gouge's spring when their well went dry. The Hopsons used this wagon made by son-in-law Alvin White to carry the water barrel. Kenneth Street, a neighbor, and an unidentified little girl sit on the wagon, while (from left to right) Carmen, Ross, Terry, and Hassie Hopson stand behind, smiling as they pause on their way to the spring. (Courtesy of Terry Hopson.)

IMAGES
of America

UNICOI AND LIMESTONE COVE

Janice Willis Barnett

ARCADIA
PUBLISHING

Published by Arcadia Publishing
Charleston SC, Chicago IL, Portsmouth NH, San Francisco CA

Printed in the United States of America

Library of Congress Control Number: 2009927249

For all general information contact Arcadia Publishing at:
Telephone 843-853-2070
Fax 843-853-0044
E-mail sales@arcadiapublishing.com
For customer service and orders:
Toll-Free 1-888-313-2665

Visit us on the Internet at www.arcadiapublishing.com

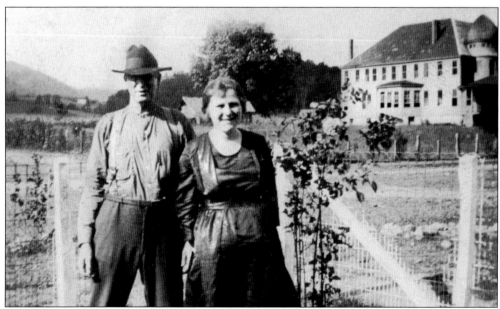

Isaac and Margaret Erwin stand in their yard on Massachusetts Avenue in the early 1900s with the old Unicoi Hotel visible in the background. The hotel, which has become an icon of early Unicoi, would have been serving as a school at this time. (Courtesy of Jack Snider.)

CONTENTS

ACKNOWLEDGMENTS

The writing of this book involved the kindness and generosity of many individuals. Judy Carson, the author of Arcadia's book on Altapass, North Carolina, encouraged me to submit a proposal to Arcadia and gave me invaluable guidance as I completed it. Janice Crall, Geraldine Love, and Howard Street were the angels who provided pictures to go with the proposal.

Others who went the extra mile in providing information and encouragement are Beulah Barry, Harold Burleson, Martha Erwin, Dan Garland, Tom and Nadine Gouge, Edith Hawkins, Terry and Speedy Hopson, John Marcus, Chuck McInturff, Teresa Simerly, Jack Snider, Bill and Shirley Wilson, and Don and Sharylene Wilson.

I am indebted to the late George Sterling and his sister Janice Crall for their fine work in preserving the history of the Schultz and Cochran families in Limestone Cove. I thank Robert Cochran and Elsie Garland for loaning me copies of the books and thank Dale Crall for scanning pictures that had been used in the histories and sending them to me.

My thanks go to Jack Davis for his kindness and for sharing material gathered in his efforts to preserve Limestone Cove's history and heritage at Davis Springs. I am grateful to *Erwin Record* publisher Mark Stevens for his encouragement and help, and to Unicoi County Historical Society president Chris Tipton for sharing her vast knowledge of local history. I also appreciate Arcadia editor Maggie Bullwinkel's assistance and patience, especially with helping me learn how to scan the pictures correctly.

I am indebted to Anderson Pate for information on the old schools in Unicoi and Limestone Cove, and to the late Col. Talmadge McNabb for information from his fine articles printed in the *Erwin Record*.

Many thanks to my friends Britt, Dallas, Katey, Mendy, Peg, and Vic for helping me hold onto the vision for this book.

My deepest gratitude goes to my husband, Leo Barnett, for all the proofreading he did and for his continuing love and support as I made my way through this project.

May each of you who contributed photographs be forever blessed for helping me give this gift to our community.

INTRODUCTION

The town of Unicoi and the Limestone Cove community were part of the Cherokee Indians' hunting grounds when white hunters and traders penetrated the area in the early 1760s. As these traders and long hunters (so called because of their lengthy hunting trips) carried news of the land's abundant wildlife back to the colonies of North Carolina and Virginia, white settlers crossed the Appalachian Mountains and formed the Watauga and Nolichucky Settlements in the early 1770s.

Though the geographical boundaries are vague, Limestone Cove was part of the Watauga Settlement, while part of Unicoi belonged to the Nolichucky Settlement. After Tennessee became a state in 1796, Limestone Cove was assigned to Carter County and Unicoi to Washington County until the two areas became part of newly formed Unicoi County in 1875.

Prior to the American Revolution, most settlers to Unicoi and Limestone Cove were seeking a better place to make a home for their families. They wanted freedom from Britain's colonial rule and taxation. Following the revolution, a sparse settlement of farmers (mostly of Northern European descent) lived on land either granted for service in the war or purchased from a grant given to someone else. However, population in both areas increased in the late 1800s when more industrialized parts of the country discovered Appalachia's rich natural resources.

Between 1890 and 1891, two businessmen from Virginia, Thomas C. Blair and James R. Miller, purchased thousands of acres in Unicoi and Limestone Cove, and organized two corporations to market their acquisitions. By 1892, these corporations had become the Unaka Iron Company and the Unicoi Development Company, with the International Fraternal Alliance of Baltimore providing funding for the Unaka Iron Company's ventures in the timber and iron industries, and the Unicoi Development Company's development of Unicoi.

The Unicoi Development Company envisioned Unicoi as "Unicoi City" with carefully laid-out streets and a grand Victorian-style hotel. A plat of the 800-acre township anticipated homes and businesses on blocks with streets named for states and presidents. Unicoi had what was needed to attract the attention of industrialists riding the national industrial boom of the 1880s—rail access. The Charleston, Cincinnati, and Chicago Railroad had arrived in Unicoi in 1888, thus providing a means to carry the area's abundant timber and mineral resources to other parts of the country.

Industrial timber operations also needed rail access from Unicoi to neighboring Limestone Cove in order to harvest the thick stands of timber on Stone and Unaka Mountains. Records indicate that New York industrialist William E. Uptegrove was instrumental in getting a narrow-gauge railroad into this area. In 1905, Uptegrove's American Cigar Box Lumber Company received a charter for the Johnson City, Bakersville, and Southern Railway, which ran from Unicoi to Limestone Cove and Unaka Mountain. However, this 10.7-mile narrow-gauge line may have been operating its rugged little engines on part of the route as early as 1902.

Though the mining industry never operated on as large a scale as the timber industry, rail access also spurred growth in Unicoi and Limestone Cove's iron ore operations, which had existed since the early 1800s with only a local outlet for sales. Deeds from 1893 show Blair and Miller's Unaka Iron Company selling land on the south side of Unaka Mountain to the Ferguson Land, Iron, and Mining Company. Blair and Miller also operated an ore washer on Scioto Creek with a nailery located nearby. Many deeds recorded during the days of the Unaka Iron Company refer to ore banks in Unicoi and Limestone Cove. The little timber trains that hauled logs and lumber also carried iron ore to the standard-gauge line in Unicoi for shipment to waiting markets.

By 1902, George L. Carter had purchased the Charleston, Cincinnati, and Chicago rail line to Unicoi and had renamed it the South and Western Railway. Investors in Blair and Miller's land companies hoped Carter would locate the railroad's repair shops in Unicoi. Instead, in 1908, Carter chose Erwin, 6 miles south, for the location. As a result, Erwin, rather than Unicoi, became the center of growth in Unicoi County.

The aforementioned grand hotel, which had provided lodging for investors in Blair and Miller's enterprises, had already changed ownership by the time Unicoi lost the anticipated railroad shops. By 1904, the General Conference of Free Baptists, headquartered in Maine, had purchased 1,000 acres in Unicoi, including the grand hotel, for the purpose of establishing an industrial school for Free Will Baptists. Though the industrial school never materialized, a Free Will Baptist parochial school under the supervision of J. W. Lucas operated in the hotel for several years. In 1919, the Unicoi County School System successfully completed negotiations begun in 1916 to purchase the building and grounds for a public school.

During the time that the General Conference of Free Baptists owned much of the Unicoi town site, many Free Will Baptist families bought lots and moved there. However, without the growth that the railroad shops and the industrial school would have brought, Unicoi became a village rather than a town.

Another factor that affected its growth was the decline of the timber industry. By 1920, industrial timber operations had clear-cut much of the forested land surrounding Unicoi and Limestone Cove. In 1923, the federal government purchased this damaged acreage and incorporated it into what is now the Cherokee National Forest. As part of the Emergency Conservation Work Act, the government also built Tennessee's first Civilian Conservation Corp facility, Camp Cordell Hull, between Unicoi and Limestone Cove in 1933. The major task of the camp's enrollees was to restore the mountain land.

The only known surviving photograph of the old Unicoi town site shows the outline of Stone and Unaka Mountains in 1907 before all the timber was cut. Supposedly taken from the hill where Swingle Cemetery is located, the scene is different from, yet similar to, today's view from the hill. In the picture from 1907, the old hotel towers over the buildings clustered around it. Today the spot where the hotel stood before burning in 1935 is the site of the playground for the Unicoi Elementary School, a sprawling redbrick, one-story building. Much of the land behind the hotel, still vacant in 1907, is now filled with houses. Four church spires have joined that of the old Unicoi Church of Christ, which was built in 1893: those belonging to the Methodist, Missionary Baptist, Free Will Baptist, and Church of God denominations. However, the horizon line formed by the Stone and Unaka Mountains is the same, and many of today's residents have the same names as Unicoi's early families.

Unicoi was still a village in 1907, but it is now an incorporated town. In 1994, residents voted for incorporation in order to prevent feared annexation by nearby Johnson City. However, neighboring Limestone Cove remains an unincorporated community. Today both communities are receiving an influx of newcomers with subdivision development on much of the old farmland. As Unicoi and Limestone Cove move into this new chapter in their history, plans are underway for establishing heritage centers in both areas to honor the past. Meanwhile, the blue hills of the Cherokee National Forest still surround them, providing the backdrop for whatever their future holds.

One

FAMILY TIES
UNICOI

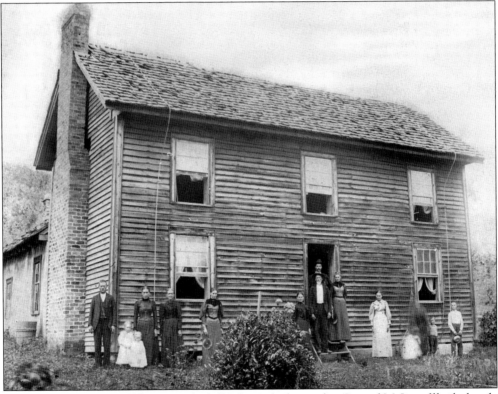

Still referred to as the "old house on the hill," this is the home that Samuel McInturff built shortly after returning from the Civil War. Pictured here in the early 1900s, Samuel is the older man standing on the bottom step in front of the open door. Members of Samuel's family pose with him in front of the house. From left to right are Samuel's son William Hendrix; two unidentified children; Hendrix's wife, Elizabeth; Samuel's wife, Sarah Katherine; Samuel's daughters Dora and Ann; Samuel with his son-in-law Will Constable (behind); Samuel's daughter Josephine (Constable's wife); Samuel's daughter Bobbie; and four unidentified. Notice the old fashioned kitchen at the back. As was common at the time, it had no inside entrance to other rooms in the house. (Courtesy of Chuck McInturff.)

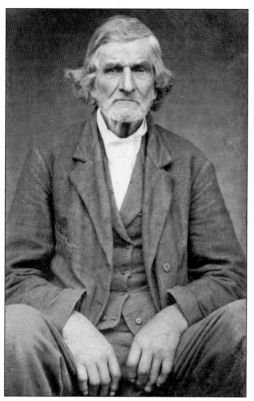

In 1854, John "Crowner" McInturff received a State of Tennessee land grant for 2,056 acres in the Dry Creek section of Unicoi, where he farmed, ran a distillery, and built a two-story log cabin, which is still standing. John was also a coroner. He acquired the nickname "Crowner" when a young boy saw him on his way to investigate a death and yelled to bystanders, "Here comes John Crowner." The boy mispronounced "Coroner" as "Crowner." (Courtesy of Chuck McInturff.)

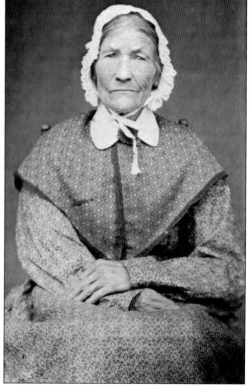

On March 22, 1818, Rachel Edna Scott married John McInturff, and the couple lived in Carter County near Milligan before homesteading in nearby Unicoi in the 1850s. Rachel bore John nine children: Mary, Emanuel, Edward, Israel, David, Lucinda Jane, Nathaniel, James Samuel, and Julia Ann. Three sons, Nathaniel, David, and James Samuel, fought in the Civil War. (Courtesy of Chuck McInturff.)

Solomon Hendrix Jones, born in 1813, was the son of William B. and Nancy Kuhn Jones and the grandson of Revolutionary War veteran Darling Jones. Solomon owned a large farm in the Dry Creek community. His first wife was Elizabeth Baker, and his second wife, pictured here, was Juliann Haun. (Courtesy of Euretha Anderson.)

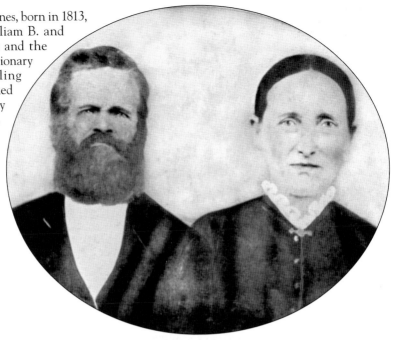

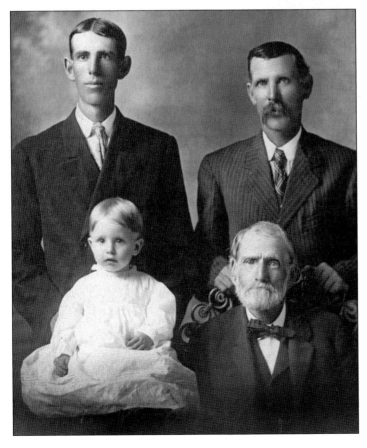

Four generations of the Anderson family in the Marbleton community are represented here. From left to right are (seated) Henry Neil Anderson and Shepherd Monroe Anderson Sr.; (standing) Shepherd Monroe Anderson Jr. and Isaac Anderson. They are descendants of early Marbleton landowner Isaac Anderson. (Courtesy of Dr. James Ray.)

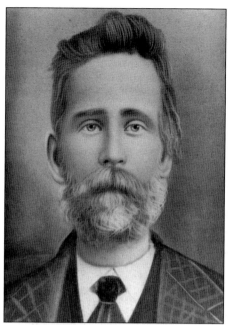

From the mid-1800s until his death in 1889, John Augustus Anderson was a prosperous farmer and landowner in the area of Unicoi that borders Carter County. His first wife was Eva Swingle, and after her death, he married Mary Anne Jones, the daughter of Unicoi pioneer Solomon Hendrix Jones. In 1887, John and Mary Anne deeded land to the Methodist congregation in Unicoi to build the Jones Chapel Church. (Courtesy of Richard Allen Anderson.)

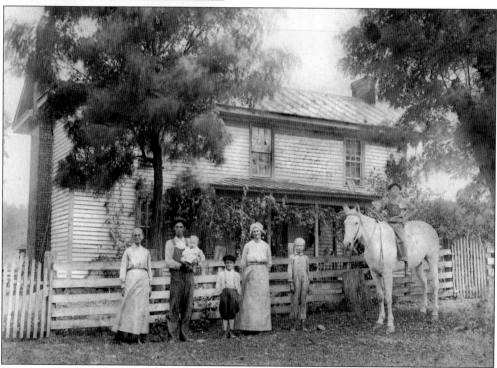

Members of the Anderson family stand in front of the John Augustus Anderson home in 1913. From left to right, they are Mary Anne Anderson, Frank Anderson holding baby Benjamin, Ernest Anderson, Hattie Peoples Anderson, Robert Anderson, and Ralph Anderson on the horse. Mary Anne was known for her industriousness, kindness, loyalty, and strong will. She mothered six children of her own plus three stepchildren and five foster children. (Courtesy of Euretha Anderson.)

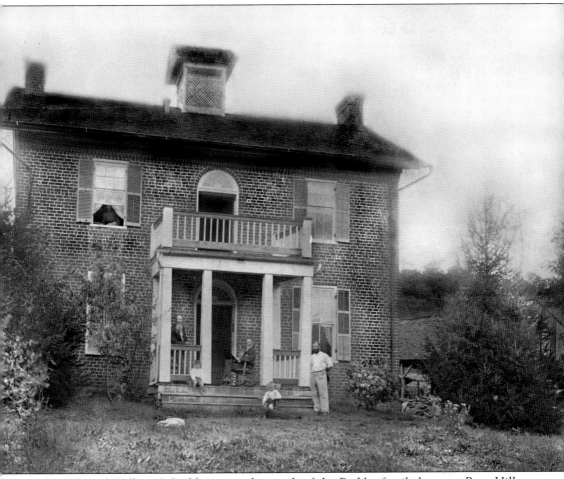

Madison T. and William J. Peebles sit on the porch of the Peebles family home at Rose Hill, as this area was called in the 1800s. Madison, born on January 2, 1825, and William, born on January 18, 1831, were the sons of William and Elizabeth Sheetz Peebles. During much of their adult life, Madison and William lived together in the old family home and tended their father's farm. Madison also practiced medicine. William was a civil engineer and served in the Confederate army. In 1896, William married Mary Lyon. Both Peebles brothers were dedicated Masons. Today the Peebles farm is home to the Farmhouse Gallery and Gardens, which is owned and operated by Unicoi mayor and wildlife artist Johnny Lynch and his wife, Pat. (Courtesy of Pat Lynch.)

Pictured here around 1920 is young Sam Orville McInturff with his uncle Will Constable, the husband of Josie McInturff. Will was a builder in early Unicoi. Like his uncle, Sam Orville also became a respected carpenter and builder. (Courtesy of Peggy McInturff.)

Cordelia "Delia" White, pictured here in the late 1920s, married Sam Orville McInturff, a neighbor boy. Her descendants still remember stories about how hard she worked and what big meals she cooked when workers came to thrash wheat on the McInturff farm. Sam Orville and Delia had two sons, Paul Clint and William Hendrix McInturff. (Courtesy of Peggy McInturff.)

In 1908, Lelia McNabb married Shep McInturff, and years later, she told her nephew Col. Talmadge McNabb that during 52 years of marriage and the raising of 11 children, they never had a quarrel. In a story in the *Erwin Record*, Colonel McNabb noted that his aunt Lelia's life "was concrete evidence that life's meaning and ultimate goal lies not in doing big things in the world, but in being faithful to small opportunities." Shep was a farmer, known for his integrity and industriousness. (Courtesy of Hazel Berry.)

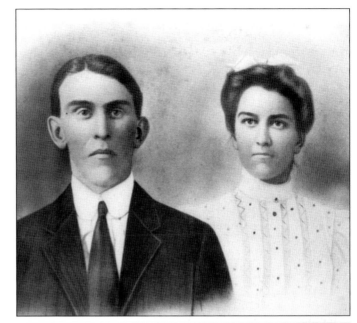

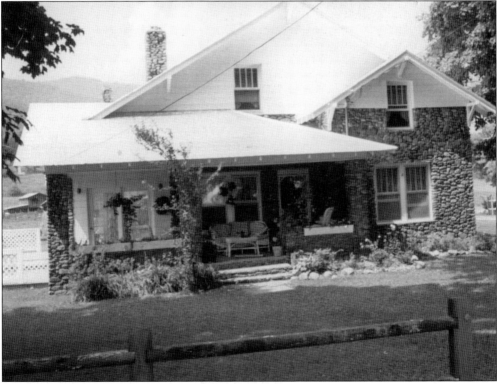

In 1929, workers completed Shep and Lelia McInturff's 11-room stone house on Massachusetts Avenue. The older McInturff girls gathered stones from North Indian Creek and hauled them in a mule-drawn wagon to the masons doing the stonework. Since the house was one of the few in Unicoi with an indoor bathroom, neighbors often asked to use the bathtub. (Courtesy of Hazel Berry.)

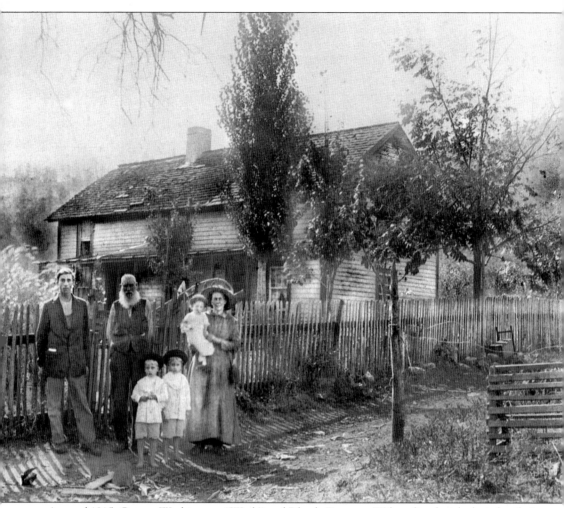

Around 1915, George Washington "Wash" and Rhoda Peterson Wilson lived with their family in this house on the old Bradley place, near where Scott's Farms is now located. Standing, from left to right, are Wash Wilson; his father, Ned Wilson; and Rhoda holding baby Ernest. The twins, Earl and Erful, are in front in matching outfits. In the late 1880s, Wash helped lay the first railroad tracks in Unicoi. He farmed and was known for his generosity and community spirit. Wash also donated land for the Unicoi Free Will Baptist Church and helped build it. Rhoda was a devout Free Will Baptist, gave birth to nine children, and was respected in the community as a healer. She had the ability to cure colic and make warts disappear. (Courtesy of Don Wilson.)

Taken on May 19, 1925, this is Sam Jones and Nola Banks's wedding picture. Sam was descended from early Unicoi settler Solomon Hendrix Jones. He and Nola had five children: Sam Jr., Roy, Agnes, Margaret, and Everett. Sam Jr. established and ran Jones Hardware in Unicoi. (Courtesy of Tom Gouge.)

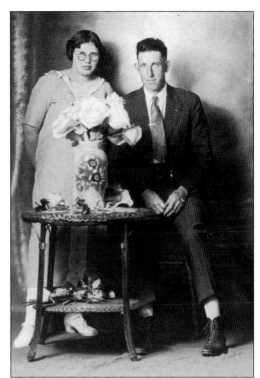

In the late 1890s, Dosser William and Martha Anne Street Buchanan moved from North Carolina to Limestone Cove, where they lived before moving to Unicoi. A prominent man, Dosser served as county judge (magistrate), postmaster, and mail carrier. He insisted that his children be educated. His son John became a medical doctor, and his son Arthur, along with several of his daughters, became teachers. From left to right are (seated) Dosser, Martha Anne, Melissa, and Berta; (standing) Arthur, Dr. John, Alice, Mary, Frank, and Monta. (Courtesy of Martha Erwin.)

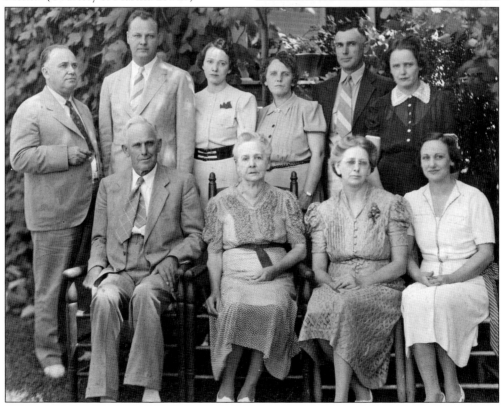

In this 1910 photograph, Belle Laws appears proud of her pretty winter coat and its matching muff. Notice the special snow effect in the picture. When Belle grew up, she married Frank Troutman. In the 1930s and 1940s, they ran a general store in Unicoi. Belle is also remembered for her column about Unicoi, which was published in the *Erwin Record*. (Courtesy of Alma Cates.)

The occasion that prompted this photograph of these serious-looking young men with their feathery Kewpie doll canes is unknown. Paul White (left), born in 1907, and Mack Jones, born in 1906, were close friends while growing up in Unicoi. (Courtesy of Howard Street.)

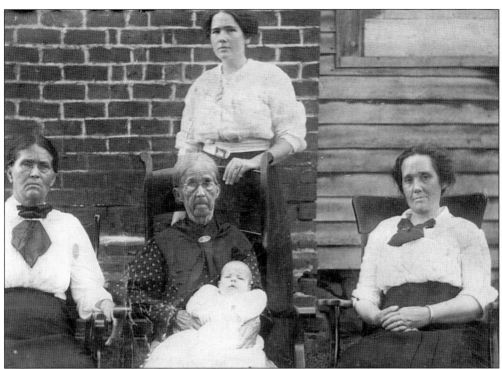

The women in Ray Thomas Briggs's family were known for their strong wills and strength of character. In this 1913 picture, baby Ray's great-great-grandmother Charity Moore holds him while his mother, Effie Byrd Hensley Briggs, stands behind them. Sitting beside Moore on the right is Ray's grandmother Mary Anne Briggs Hensley, and on the left is his great-grandmother Lyda Moore Briggs. (Courtesy of Sandra Irwin.)

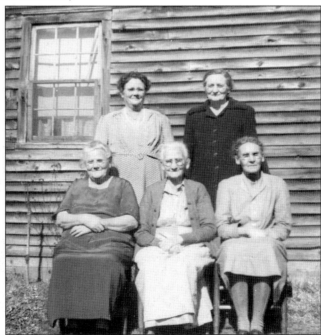

The good humor and strength in the faces of these women of the Great Depression indicate that they were women who did not give up when times were rough. This picture was taken at the home of John and Nancy Whitson Norris in the late 1930s. From left to right are (seated) Hattie Brummett, Nancy Norris, and Minnie Tinker; (standing) Donnie Brummett and Abbie Little. (Courtesy of Edith Hawkins.)

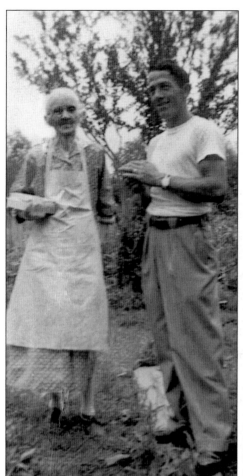

Mary Smith married Labe White in 1898. Their children were Sol, Tom, Opal, Chester, Russell, Pearl, and Leata. Mary was self-educated and a well-read woman for her time. Her family remembers her as an outgoing people person. Notice the book in Mary's hand as she stands talking with M. C. Culbertson. (Courtesy of Shirley Wilson.)

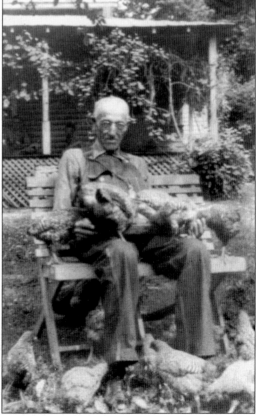

Pictured around 1939, Labe White is surrounded by his Rhode Island Red and Dominecker hens. He is remembered as a kindly, hardworking man, who was greatly respected by his neighbors in the Dry Creek community. Labe and his family grew almost everything they ate, including the grapes on the beautiful arbor behind him. Labe's granddaughter Shirley Wilson recalls that he taught her a great appreciation for nature. (Courtesy of Shirley Wilson.)

Thelma (first row, left) and Gladys were the oldest of Monroe and Bert Erwin Street's five children. Bert was a much loved and respected midwife in the Unicoi community. Monroe worked for the Clinchfield Railroad in the early 1900s, building track and tunnels. Later he joined the Unicoi County Road Department and supervised the construction of many of its wooden bridges. (Courtesy of Howard Street.)

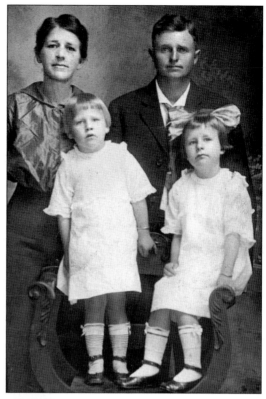

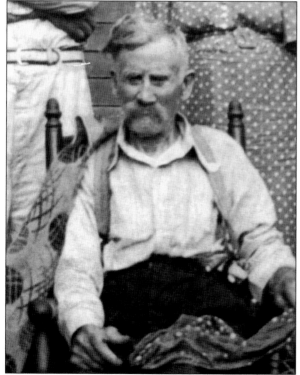

This picture of William Finley Horton was taken in the 1930s. He married Rosalynn Bennett, and they lived in Jack's Creek, North Carolina, before settling on a farm in the Buffalo section of Unicoi in the late 1890s. William and Rosalynn were the parents of Zephaniah Frazier Horton and the grandparents of Milton Horton. (Courtesy of Betty Head.)

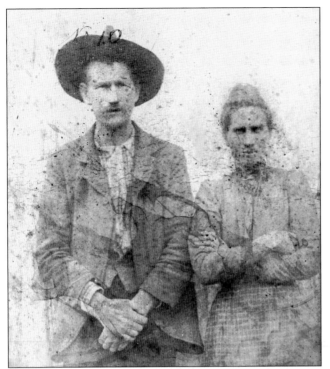

Samuel Peter and Mary Hedrick Howell moved from Yancey County, North Carolina, to Unicoi in the late 1800s, where they bought several lots on Riverside Avenue and built a home. Samuel had a blacksmith shop near the government spring off Highway 107. He also invested in timber, farmed, and worked as a carpenter. (Courtesy of Bob Howell.)

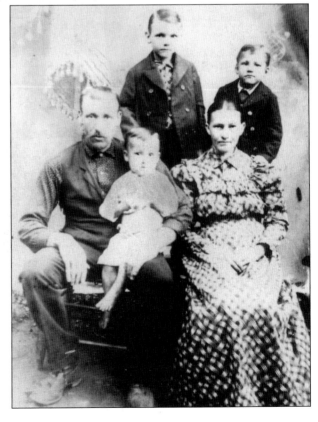

Joseph White married Mary McInturff. Pictured here around 1905, Joseph and Mary's son Walter sits in his father's lap, and their sons James (left) and Everett stand behind them. Their daughter, Bessie Bell, was born later. Joseph was the son of Civil War veteran John Christopher White. (Courtesy of John Vinton White.)

In 1906, John N. Yarber married Rachel Garland, and in 1918, they moved to Buffalo Valley in Unicoi. Here John and Rachel stand behind their eldest child, Ruth, and their baby, Edith. John worked for the Clinchfield Railroad in the 1920s. He and Rachel had seven children: Ruth, Edith, John II, Harry, Jack, Carrol, and Alma. John was a Spanish-American War veteran. (Courtesy of Jack Yarber Jr.)

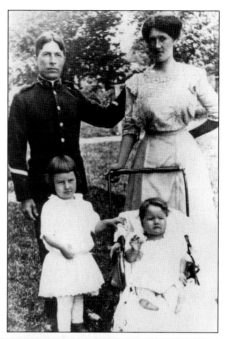

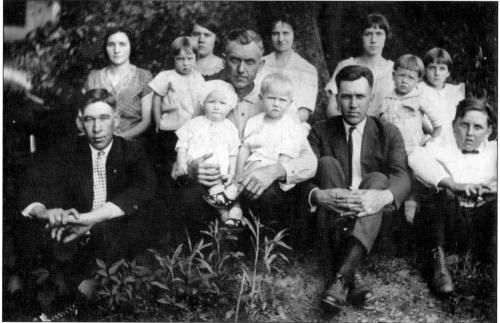

In the early 1920s, Carl Conley was the first of the Dock and Vena Conley family to move to Unicoi. Carl's sisters Pansy and Ada came shortly thereafter. Pansy married David Brummett, and Ada married Carl McInturff. Pictured here in the 1920s, the adults are, from left to right, (first row) Carl McInturff and Dock, Carl, and Orville Conley; (second row) Ada McInturff and Pansy, Rose, and Margaret Conley. The identified children pictured are (first row) Joe McInturff (left) and Bob McInturff. Carl and Ada McInturff ran a store in Unicoi. Carl also served as the Unicoi County sheriff and was prominent in state and local politics. The children are unidentified. (Courtesy of June Elliott.)

In their later years, Samuel McInturff's daughters, pictured here, were known as the old women in the house on the hill. From left to right, Bobbie, Dora, and Josie stand in the living room of the house their father built shortly after the Civil War ended. As late as the 1960s, they raised hogs, milked their cows, and raised a garden. The McInturff sisters also did much to keep the nearby Jones Chapel Church alive after part of the congregation left to build the Unicoi United Methodist Church. (Courtesy of Peggy McInturff.)

Frankie McInturff, the granddaughter of Samuel McInturff, sits beside a window in the old McInturff house, where she lived with her aunts, Bobbie, Dora, and Josie. Frankie was well known for raising chickens and selling eggs in the Unicoi community. She loved the Jones Chapel Church and often worked to earn money to help keep it in good repair. Frankie was 93 years old when she died in 1988. (Courtesy of Peggy McInturff.)

Jacob "Jake" Hopson Sr. and his wife, Hassie Peterson, moved from North Carolina to Unicoi in the early 1900s. Pictured here in the 1930s, the Hopson family is gathered in front of their home on Massachusetts Avenue. From left to right are (first row) children Terry, Johnnie, Speedy, and Ross; (second row) parents Jacob Sr. and Hassie; (third row) son-in-law Alvin White and his wife, Edith Hopson White; and Jacob Sr. and Hassie's children Eugene, Ellene, Jacob Jr. "Jay," and Earl. (Courtesy of Terry Hopson.)

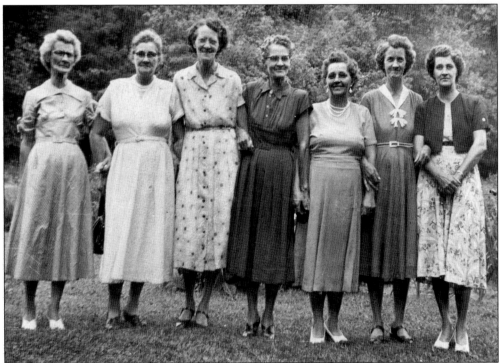

Charles and Hannah Peterson had seven daughters and three sons. On a warm day in the 1940s, the daughters gathered for this picture. From left to right are Emma, Hassie, Gustie, Allie, Sue, Julie, and Ida. (Courtesy of Speedy Hopson.)

Mary Erwin Snider smiles as she holds her son Jack, born on August 18, 1921. Throughout his life, Jack did much to make his mother and his father, Isaac Newton Snider, proud. Before earning his doctorate, he taught in the Unicoi County school system and was an interim superintendent of schools. Later Jack worked at the King College in Bristol, Tennessee, for 50 years. He was a senior vice president and did extensive fund-raising for the school. The honors center at King College is named for him. Jack served as the national secretary for Ruritan National, was president of the Ruritan Foundation, and is a member of the Unicoi Ruritan. He also donated land for the site of the future Tanasi cultural arts center in Unicoi. (Courtesy of Howard Street.)

Erful Wilson and Venie Lyle are courting in this picture from the late 1920s. After marrying, they had three children, Mary Alma, Don, and Edward. Erful was a supervisor at North American Rayon. Venie was known for her pleasant disposition, and Erful was best known for his unusual name. He was born after his twin brother, Earl, and when the midwife told his mother there was another baby, she said, "Oh my, that's awful" and named him *Erful*. (Courtesy of Don Wilson.)

In the 1940s, the family of George Washington "Wash" Wilson and his wife, Rhoda, gathered at the Wilson home on Lincoln Street for a reunion. Wash and Rhoda are sitting on the first row (far right). Their children were John, Mallie, Nelson, Burnie, Jeff, Rosa, Earl, Erful, and Ernest. (Courtesy of Don Wilson.)

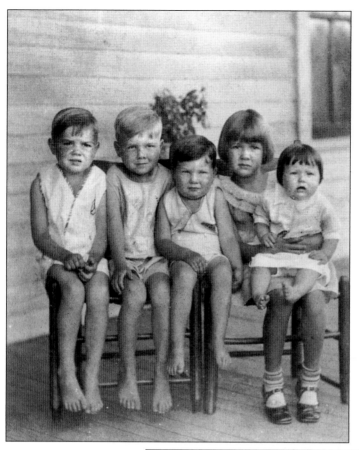

One summer day in 1932, June Brummett helped her mother, Pansy, get her brothers and little sister spruced up for this picture made by a traveling photographer. Notice June's shiny black patent-leather slippers. She was the only one who agreed to wear shoes. After growing up, June married W. T. Elliott Jr., and they had two children, David and Debbie. June also worked in the Unicoi County Executive's Office for 25 years, and while there, she designed the official seal of Unicoi County, which was adopted for the county's centennial in 1975. From left to right, the Brummett children are Bert, David "D. C.," Fred, and June, who holds baby Maye. (Courtesy of June Elliott.)

In 1926, when David Brummett married Pansy Conley, he had this house on Massachusetts Avenue built for them. Though the picture has faded with time, memories of David and Pansy's generosity and neighborliness have not. The Brummett children still recall Pansy serving biscuits and ham to hobos who found their way to her door in the 1930s. She justified this by saying she never knew when she might be feeding an angel unaware. (Courtesy of June Elliott.)

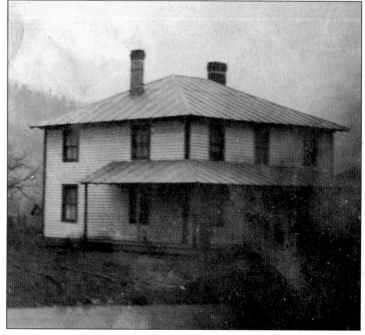

28

Pictured here in the 1940s, Nat Linville stands beside his wife, Bessie, and holds his granddaughter Patsy. Bessie was a homemaker, and Nat worked for Clinchfield Railroad. Nat was also the song leader for the Jones Chapel Church and sang in a quartet with his brothers Robert, Sam, and Danny. He was descended from the family for whom the Linville Caverns in North Carolina is named. (Courtesy of James Linville.)

On November 9, 1947, James Linville and Pauline Black slipped off in James's father, Nat Linville's, old 1930s truck to get married. They feared their Methodist minister might tell James's parents, so they had the Baptist minister in Unicoi perform the ceremony. Pictured at left, James and Pauline have been married about a year. Their children are Keith, Larry, and Jeff. (Courtesy of James Linville.)

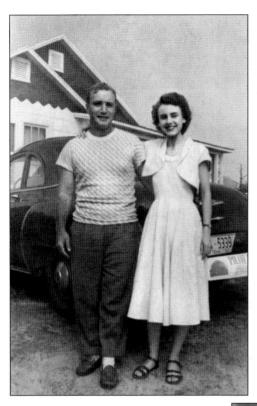

Jack and Betty Horton Head were married on June 28, 1950. Here they are on their honeymoon in Wilkesboro, North Carolina. During their 49-year marriage, Jack and Betty did much genealogical work, delving into the ancestry of the Head and Horton families in Unicoi. Before his 1999 passing, Jack especially enjoyed keeping up with former Unicoi Elementary classmates and helping with their annual reunions. (Courtesy of Betty Head.)

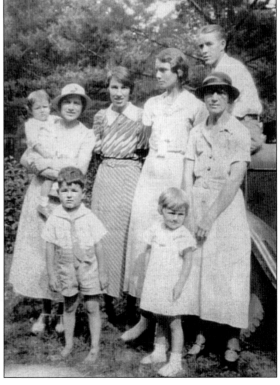

Pictured in 1934, these members of the Horton, Miller, and Hawkins families look as if they are on a Sunday outing. From left to right, the adults are Beulah Hawkins Horton (holding son Joe), Pearl Hawkins Miller, an unidentified woman, John Miller, and Sally Hawkins. Beulah's children, young Bill and Betty Horton, stand in front. (Courtesy of Betty Head.)

Harley and Ruetta Howell Bryant moved from Yancey County, North Carolina, to Unicoi in 1935. This picture shows them before the move, at a 1933 outing to Huntdale Bridge in Yancey County. Harley and Ruetta had three children, Furman, Faith, and Hope. (Courtesy of Furman Bryant.)

In the early 1940s, little Edna Pauline McCourry is having her picture made while her mother, Gladys Elizabeth McCourry (left), and her aunt Zelma McCourry Watson try to hold her in the chair and look toward the camera at the same time. (Courtesy of Phyllis White.)

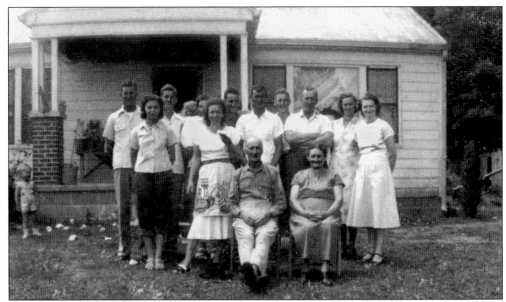

On a warm day in 1950, during a family get-together that included a large meal, Garrett and Byrdie Edwards (first row) had this picture made with their children. From left to right are (second row) children Anne, Mayfra, Bill, Harley, Vergie, and Sharmalee; (third row) Paul, Guy, Beryle (holding her daughter Linda), Hartsell, and Pat. Belle was not present. Rosetta, Wayne, and Alice were deceased. The little boy on the far left is unidentified. Garrett and Byrdie moved to Unicoi in 1939. (Courtesy of Hartsell Edwards.)

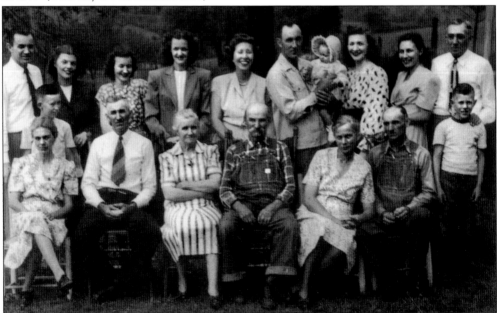

In 1908, Gutch and Isabella Garland moved from Red Hill, North Carolina, to a farm in the Marbleton community. Pictured here in the 1950s, Gutch (first row, fourth from left) is surrounded by his and Isabella's family. Shown from left to right are (first row) Celie, Dave, Joann, Guth, Ida, Frank, and Bill; (second row) Lewis, Evelyn, Daisy, Charlotte, Mary, Clyde holding baby Sharon, Bessie, Lucille, and Gene. (Courtesy of Alvin Garland.)

Bob (first row, left) and Mike Howell were blessed with a beautiful and loving mother, Ethel Howell (second row, right), and two dedicated grandmothers, Mary Howell (second row, left) and Elzora Vance (second row, center). Pictured here in the 1940s, the boys and their mother and grandmothers are on an outing to the Great Smoky Mountains National Park. (Courtesy of Bob Howell.)

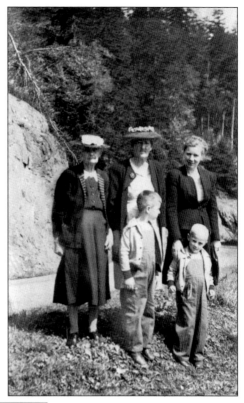

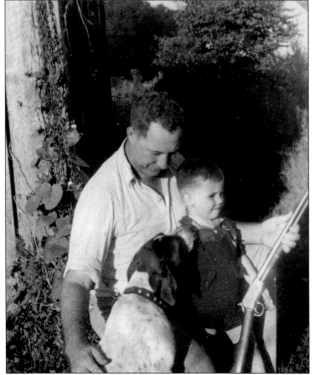

From an early age, Lester Howell (left) taught his sons, Bob and Mike, to appreciate hunting in the woods surrounding Unicoi so they would be responsible hunters when they were older. This picture from the early 1940s clearly shows the love between Lester, Bob, and their dog Rock. (Courtesy of Bob Howell.)

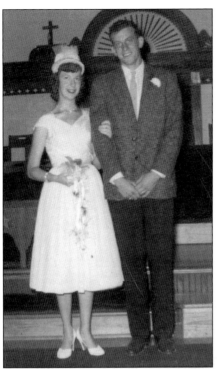

After William "Bill" Hendrix and Peggy Morelock McInturff married in 1955, they moved to a house in Unicoi with no indoor plumbing, and it was difficult for Peggy. But love conquered all, and after three years of Bill's work on a new house, the couple moved into a beautiful home with indoor plumbing and several more rooms, including two bathrooms. Bill was a builder by trade, and Peggy was a school librarian and administrative assistant. (Courtesy of Peggy McInturff.)

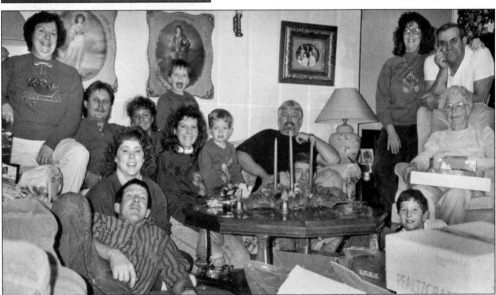

This 1990 picture shows members of William "Bill" Hendrix and Peggy McInturff's family having their annual Christmas celebration at Bill and Peggy's home. Bill was a descendant of early Unicoi homesteaders John "Crowner" and Rachel McInturff. From left to right are (first row) son Chuck McInturff and grandson Matthew Doty; (second row) daughter-in-law Debi McInturff, son-in-law Lonnie Doty, and Peggy's mother, Dessie Morelock; (third row) Peggy McInturff, unidentified, daughter Kim McInsturff, grandson Joshua Hopson behind daughter Teresa Doty, who is holding Ben Doty, son-in-law David Hopson, daughter Carolyn Hopson, and Bill McInturff. (Courtesy of Peggy McInturff.)

Two

FAMILY TIES
LIMESTONE COVE

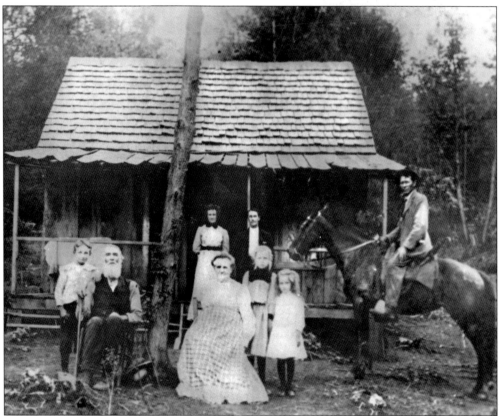

James Whitfield Cochran married Darthula "Tude" O'Brien in 1865. In this scene from the early 1900s, James and Tude sit in front of their shake-roof home with their daughter Bridgett and her family. Standing beside James and Tude, from left to right, the children are George, Myrtle, and Blanche Schultz, with Bridget and her husband, Jack Schultz, in back. The horseman is unidentified. (Courtesy of Janice Crall.)

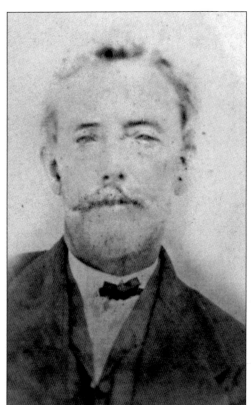

David Bell was born in Northern Ireland and went to live with his brother Henry in Baltimore, Maryland, while still a boy. He studied medicine and married Sarah McKeldin before moving to Limestone Cove around 1854. Dr. Bell served as one of the commissioners appointed to organize Unicoi County in 1875. An 1893 obituary written by his grandson David Sinclair Burleson notes Dr. Bell's "extensive medical practice" and pays tribute to his "genial wit and conversation, perfect adaptation to all classes of society, and warm hospitality." (Courtesy of E. Harold Burleson.)

Born 1818 in Baltimore, Maryland, Dr. David Bell's wife, Sarah, was the daughter of Joseph and Mary McKeldin. Sarah was at the Bell home in 1863 when Confederate soldiers laid siege to the house, massacred eight Union recruits encamped on the premises, and killed Dr. Bell's brother James. Sarah and Dr. Bell had four children: Henry Edward, Jane, Sarah Alice, and David Sinclair. (Courtesy of E. Harold Burleson.)

Dr. David and Sarah Bell's first child, Henry Edward "Eddie," was born in 1845, while the couple still lived in Baltimore. In 1875, Eddie married Nancy Harriett Miller, daughter of Jacob and Julia Miller, and they lived with his parents in Limestone Cove before moving to their own home. Eddie and Harriett's children were James, Minnie, Jacob, and David. (Courtesy of Hattie Bell.)

Born on May 24, 1879, James William Bell, the son of Henry Edward and Harriett Bell, was a farmer and a casket maker. He married Celia Garland in 1904. Their children were Virginia, William, Bessie, Gladys, Minnie, George, Florence, and Eugene. (Courtesy of Hattie Bell.)

Born on August 11, 1883, Jacob Beeler Bell was the son of Edward and Harriett Bell and the grandson of Dr. David Bell. Jacob married Florence Charles. Their children were Jack, Robert, James Roy, and David Hassell Bell. Jacob was a mail agent for the Carolina, Clinchfield, and Ohio Railroad in Unicoi. He was also a photographer. (Courtesy of Hattie Bell.)

Sarah Bell Garland (below, right) was the daughter of Dr. David and Sarah Bell. While a young girl, she lived with her uncle Henry Bell in Baltimore and attended school there. In 1875, Sarah married Elisha Garland, and she lived in Limestone Cove the remainder of her life. Sarah and Elisha's children were Walter David, Alice, Mamie, and Pierce Garland. Here Sarah stands beside her friend Susannah Whitehead Garland. (Courtesy of Hattie Bell.)

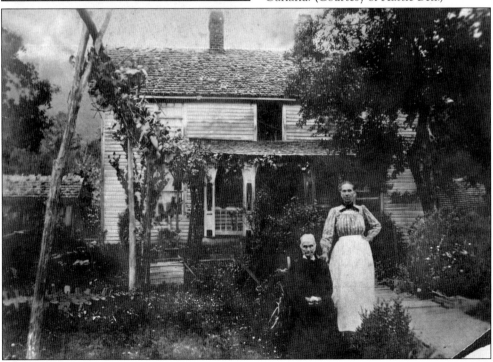

William D. O'Brien moved from Pennsylvania to Tennessee before marrying Elvina Garland in 1831. Elvina was the granddaughter of early Limestone Cove landowners Guthridge and Bridget Hampton Garland. William farmed, taught school, and, from 1870 to 1876, served as Limestone Cove's first postmaster. The O'Briens had 15 children. The child pictured here with William and Elvina is their grandson Will. (Courtesy of E. Harold Burleson.)

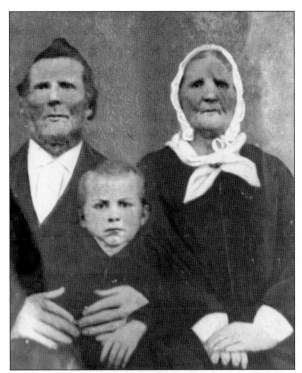

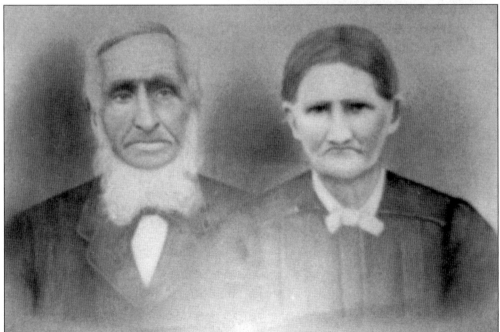

When Seth Sneyd was 13, he and his parents left Liverpool, England, for America. While aboard ship, his mother died and was buried at sea. In 1853, Seth married Martha Woodby, the daughter of Limestone Cove pioneer Epaphrododus Woodby. Seth and Martha's children were Henry, David, Sarah, Joseph, Alfred, Mary, William, John, Edmon, Jane, and Martha. (Courtesy of Geraldine Love.)

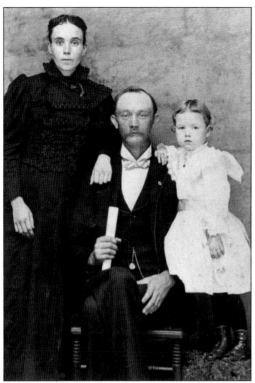

Nathan Birchfield (center) was known as the "Nimrod of the Unakas" because of his abilities as a hunter. His descendants still tell stories about the bears and wildcats he killed on Unaka Mountain. The son of Limestone Cove pioneer Ezekiel Birchfield, Nathan is pictured in the late 1800s with Caroline Hyder (left) and Lula Roberts. (Courtesy of Hattie Bell.)

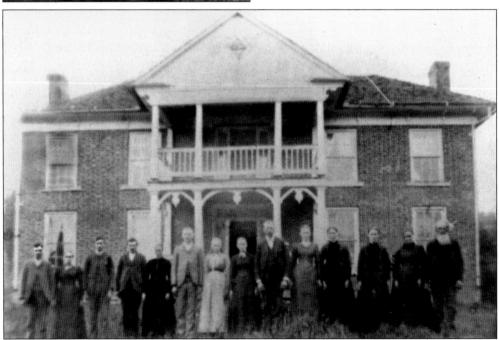

Here, in the early 1900s, Ezekiel and Sarah "Sallie" Gouge Birchfield stand in front of their home off Upper Stone Mountain Road with their 12 children. From left to right are Samuel, Annie, Isaac, Ezekiel Jr., Minerva, William, Jane, Julia, Nathan, Judith, Mary, Adaline, Sallie, and Ezekiel Sr. (Courtesy of Robert Cochran.)

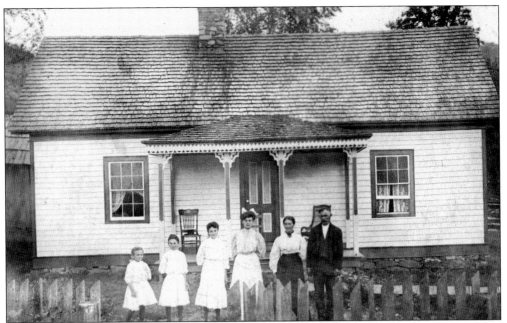

Waitsel W. Buchanan and Sarah Ann Wilson married in 1885 in Mitchell County, North Carolina, where Waitsel taught school and served as tax assessor. In 1898, they moved to a large farm in Limestone Cove. Here the Buchanan family stands in front of their neat, attractive Limestone Cove home in the early 1900s. From left to right are Norma, Millie, Venie, Nora, Sarah, and Waitsel Buchanan. (Courtesy of Norma Clark.)

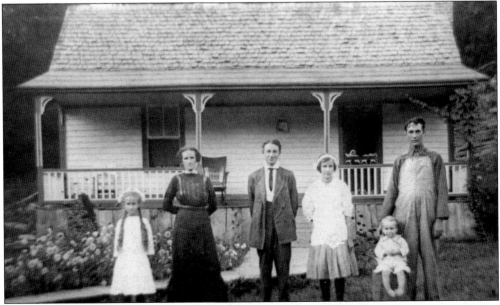

The pretty row of asters in front of Jack and Bridget Cochran Schultz's neat home is testimony to Bridget's eye for beauty. Her family remembers her as being an excellent housekeeper, cook, and banjo player. Jack helped build the narrow-gauge railroad tract into Unaka Mountain in 1898 and 1899. Pictured here around 1918 are, from left to right, Blanche, Bridgett, George, Myrtle, Harry, and Jack Schultz. (Courtesy of Janice Crall.)

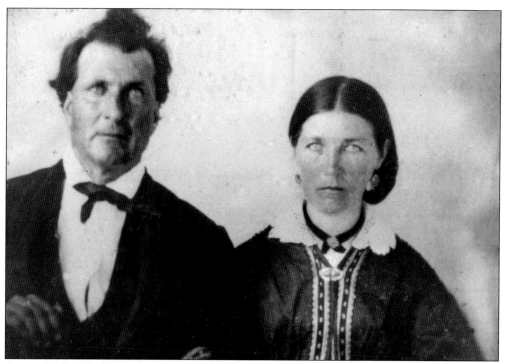

Aaron Burleson's first wife, Viann Garland, was the granddaughter of early Limestone Cove settler Gutheridge Garland. In 1884, Aaron received a land grant from the State of Tennessee for 1,600 acres of land on Iron Mountain near Red Fork Branch. While living there, Aaron and his second wife, Adeline Ledford, boarded travelers for 25¢ a night. In 1838, Aaron was part of the North Carolina infantry that accompanied the Cherokee Indians to Oklahoma. (Courtesy of E. Harold Burleson.)

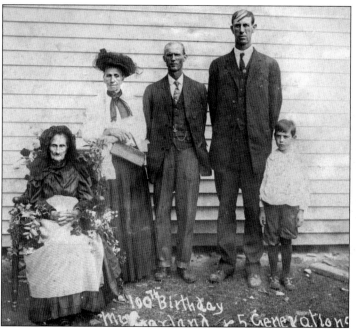

On September 29, 1912, five generations of Susannah Whitehead Garland's family gathered in Limestone Cove to celebrate her 100th birthday. From left to right are Susannah, her daughter Luvina, Susannah's grandson George Washington Pate, her great-grandson William Ezekiel Garland, and his son Jack Warren Garland. Susannah's husband was John Gutridge Garland. (Courtesy of Dan W. Garland.)

In 1868, Greenberry Burleson (standing, far left) married Jane Bell (seated, far right.) During part of their marriage, the Burlesons lived on land that had belonged to Jane's father, Limestone Cove physician Dr. David Bell. Greenberry and Jane had eight children: Mary, David Sinclair, Harriet, Jessie, Ida, Horace, Olive, and George. Greenberry and Jane are pictured here in the early 1900s with their granddaughter Christine Burleson (standing, far right) and the George Wofford family. (Courtesy of E. Harold Burleson.)

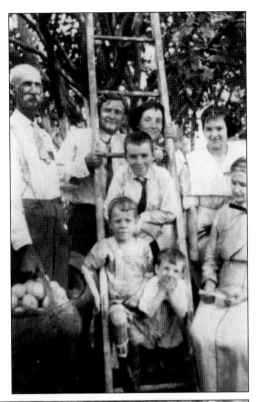

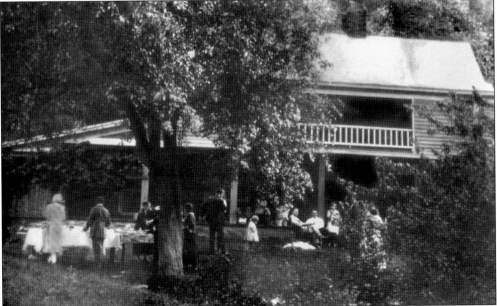

Before Henry Davis purchased this home, it belonged to Greenberry and Jane Bell Burleson. This picture captures a Davis family reunion held in the summer of 1920. Behind the adults milling about the tables and the children playing in the yard, notice the Davises' porch. In 1922, railroad strikers supposedly dynamited the house and blew the porch off the house because of Henry's negotiations in helping end a bitter strike. (Courtesy of Jack Davis.)

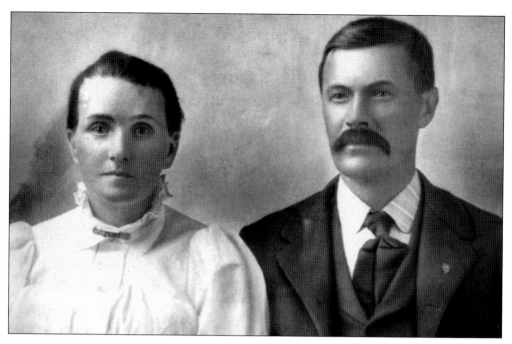

When 10-year-old Henry Davis met Lydia Gouge, he said, "That's the girl I'm going to marry," and later he did. Around 1900, the young couple moved from Buladean, North Carolina, to Limestone Cove, where they raised nine children. Years later, in 1931, Lydia walked to their mailbox, stopped to read a letter from their son Paul, and fell dead with a stroke. Henry's love for her was so great that he memorialized the spot where she died with the stone monument below. To the right of the marker is the chapel that Henry built at Davis Springs to hold an annual singing convention in Lydia's honor. For many years, on the fourth Sunday in July, thousands of people gathered there for dinner on the grounds and singing. (Both, courtesy of Jack Davis.)

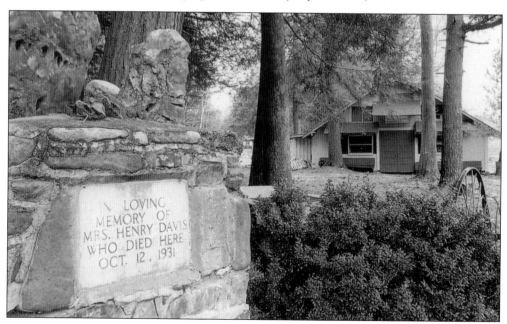

Joe Sneyd, the third generation of Seth Sneyd's family to live in Limestone Cove, had a farm off Lower Stone Mountain Road. Pictured here, from left to right, are Joe, his wife Susie, daughter Mae, and son Bill. Joe and Susie were early members of the Limestone Cove Christian Church. They were also the parents of Dave Sneyd, pictured below. (Courtesy of Geraldine Love.)

Sitting outdoors with their children Garfield (left) and Minnie in the early 1920s, Dave and Mary Sneyd are probably posing for a traveling photographer in the yard of their home off Lower Stone Mountain Road. Dave and Mary were early members of the Limestone Cove Christian Church. (Courtesy of Tom Gouge.)

Born in Limestone Cove in 1891, James S. Campbell, son of Thomas Campbell and Elizabeth Moore, worked as a miner in southwest Virginia as a young man. In 1915, he married Bessie Marcum, and they moved to Limestone Cove to raise their family. The Campbells had 12 children: John, Minnie, Bob, Mary, Bertha, Frank, David, Lucy, Harvey, Ray, Ralph, and Edith. (Courtesy of Geraldine Love.)

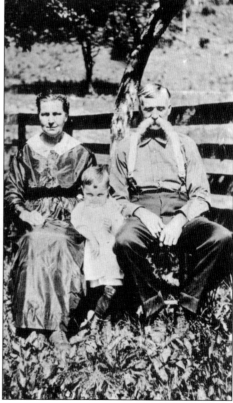

Henry McKinney, pictured here with his wife, Ellen, and their son, Dave, was a farmer and self-made dentist. He kept a gourd filled with salt that he used to fill the wound left after he had pulled a neighbor's tooth. His patients appreciated his services and paid him with chickens, eggs, and farm produce. Henry and Ellen were also the parents of Elijah McKinney. (Courtesy of Max Simerly.)

Arra Shell McKinney, daughter of Arch and Jane Shell, left a legacy as a devoted wife, mother, and teacher. Her husband, Elijah McKinney (below), died in 1924, leaving her with three small daughters, Roxie, June, and Lena. Arra taught school in both Unicoi and Carter Counties until the 1950s. She also operated a Watauga Regional Library System circulating library in her home. In her later years, Arra married Wilson McKinney (no relation). (Courtesy of Max Simerly.)

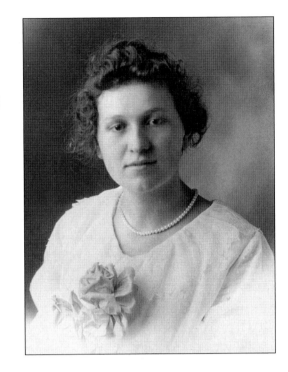

Around 1915, while engaged to pretty schoolteacher Arra Shell, Elijah McKinney traveled to Blissfield, Michigan, and worked in a sugar refinery to earn money to build them a home on the Simerly Creek farm where they would live. While in Michigan, Elijah wrote many love letters to Arra, counting the days until he could return. Elijah and Arra's descendants still have these treasured letters. (Courtesy of Max Simerly.)

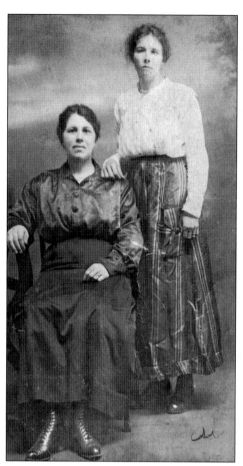

Friends Floy Vest (left) and Maggie Headrick Woodby were like sisters. Maggie was the wife of William Henderson Woodby and the mother of Violet, Viola, Dorothy, Nathan, and Bessie. (Courtesy of Nathan Woodby.)

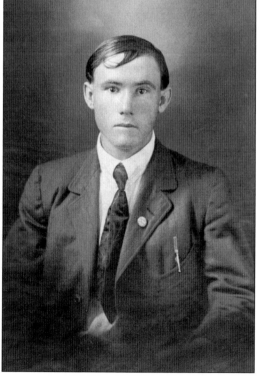

Like many mountain ministers of the early 1900s, William Henderson Woodby farmed as well as preached. Through the years, he walked many miles from his farm on Upper Stone Mountain Road to lead services at the Free Will Baptist churches he pastored not only in Limestone Cove, but in Unicoi as well. (Courtesy of Teresa Simerly.)

Clyde and Daisy Birchfield Gouge were descended from early Limestone Cove pioneers John Gouge and Ezekiel Birchfield Sr. In this 1930s photograph, Clyde holds daughter Martha Jo while sons Lynn (left) and Bill stand in front. Clyde worked for the lumber companies that logged the timber off Unaka Mountain in the early 1900s. (Courtesy of Tom Gouge.)

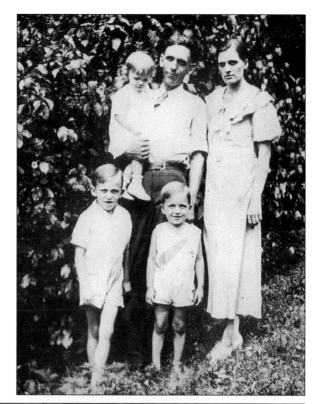

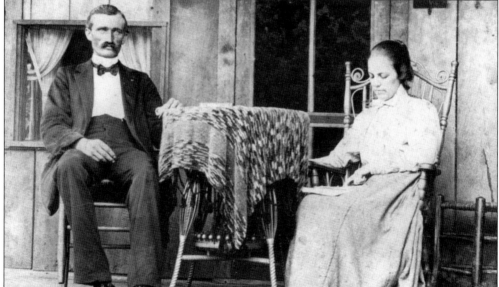

Isaac Birchfield, the son of Ezekiel Birchfield Sr., married Martha "Mattie" Riggs in 1904. This early-1900s picture shows Isaac and Mattie sitting on the porch of their home off Upper Stone Mountain Road. Their home was unusual for its time because it had carbide lighting. Isaac was a timber estimator for various lumber companies and a magistrate for the Limestone Cove district. Isaac and Mattie's children were Daisy, Mendal, Gladys, Leona, and Sanorita. (Courtesy of Tom Gouge.)

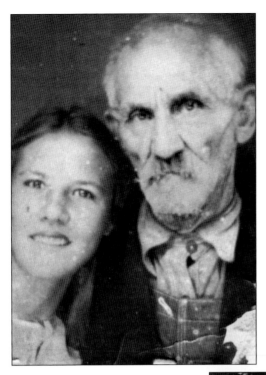

Nathan Woodby Sr. delighted in letting his grandchildren accompany him to the cemetery to place flowers on the grave where his missing arm was buried. When he died, he was buried in a plot beside his long lost arm. "Nath" is pictured here with his granddaughter Dorothy. (Courtesy of Teresa Simerly.)

In this 1930s picture, Bennett and Hill family members look as if a traveling photographer has stopped them on their way to church. From left to right, the adults are Nathan Bennett, Edith Bennett, Neptie Hill, Kern Hill, and Harry Bennett, with little Walter Compton in front. The other children are unidentified. In addition to being a talented carpenter and furniture maker, Nathan Bennett also taught at singing schools held in the mountains. He and his wife, Edith were the parents of Nadine, Gene, Ruth, Georgia, and Wileda Bennett. (Courtesy of Nadine Gouge.)

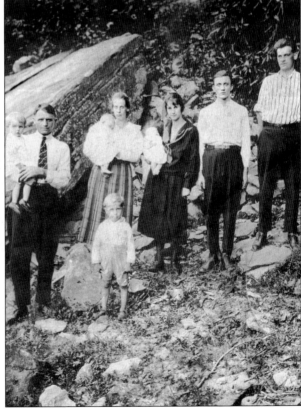

Three

WORK, PLAY, COMMUNITY
UNICOI

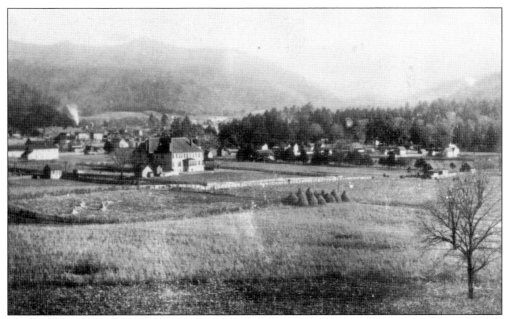

In this 1907 scene, the old Unicoi hotel is the centerpiece of Unicoi City, as Unicoi was called at the time. The Stone and Unaka Mountains outline the southeastern horizon, and to the left, smoke blows from a train on the Unicoi tracks. Unlike the original 800-acre site of Unicoi City from the early 1890s, today's incorporated Town of Unicoi includes Marbleton, Buffalo, Dry Creek, and other surrounding areas. (Courtesy of Furman Bryant.)

Dr. Frank Hannum moved to Unicoi shortly after the Civil War. In the late 1800s, Dr. Hannum and his brother, W. Y. C. Hannum, acquired and sold thousands of acres of land in Unicoi and Limestone Cove to James Miller and Thomas Blair, land developers from Virginia, who later formed the Unicoi Development Company and Unaka Iron Company. (Courtesy of Beulah Barry.)

Though he was a medical doctor, Dr. Frank H. Hannum, pictured here at his son Charles Barry's home, is best remembered as one of early Unicoi's leading businessmen. He was the community's postmaster in 1876 when Unicoi was called "Limonite," and in 1886, the Tennessee Legislature appointed him to help survey the state line between Tennessee and North Carolina. His Unaka Milling and Manufacturing Company, located near North Indian Creek, manufactured farming implements and building materials. Dr. Hannum was also vice president of the Unicoi Banking and Trust Company of Erwin. (Courtesy of Beulah Barry.)

In the late 1800s and early 1900s, this building on Massachusetts Avenue served as Unicoi's post office and Robert and Dave McInturff's Store. Standing in the doorway are Dave McInturff (wearing a vest), and Minnor Bill McLaughlin. (Courtesy of Kent Garland.)

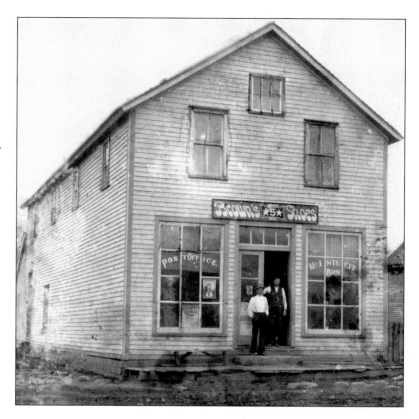

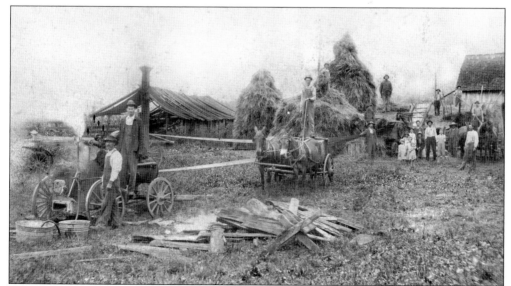

In the early 1900s, professional thrashers moved from farm to farm thrashing wheat and other grains. Pictured here, thrashers are working at Nathaniel McInturff's farm in White Cove. On the left, notice the steam tractor with its belt running to the thrashing machine near the children standing on the right. (Courtesy of Bob Howell.)

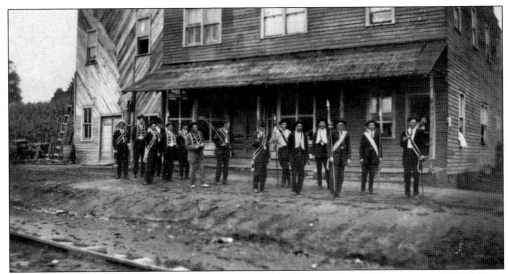

Older Unicoi residents recall that the fraternal order called the Odd Fellows met in this building in the 1940s and earlier. Similar to the Freemasons in their guiding principles, the Odd Fellows were dedicated to helping those in need in the community. Notice the members' staffs and the star-studded regalia around their necks. (Courtesy of Chuck McInturff.)

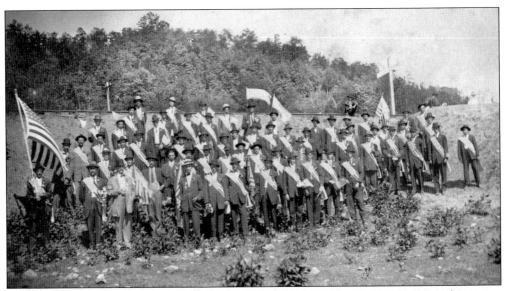

A 1929 article from the *Johnson City Chronicle* mentioned Unicoi's patriotic order Sons of America, a fraternal order that promoted patriotism and respect for national symbols such as the American flag. The order's official regalia consisted of a sash decorated with the white stars, blue background, and red and white stripes of Old Glory, as worn here by members gathered near a crossing on the Clinchfield Railroad tracks in Unicoi. (Courtesy of Chuck McInturff.)

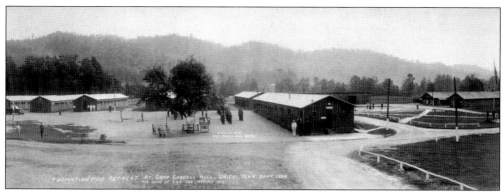

Camp Cordell Hull, established in 1933 as Tennessee's first Civilian Conservation Corp facility, consisted of Companies 1455 and 1472. Here enrollees stand in formation for retreat in 1934. These young men built telephone lines, constructed roads, and replanted burned areas in the forests. Enrollees also constructed and maintained picnic and recreation areas such as the Laurels near Elizabethton and Rock Creek near Erwin. Monthly pay for Civilian Conservation Corp servicemen was $30, and the government sent $25 of this home to their families. Camp Cordell Hull had a gym, a baseball field, and a swimming hole in nearby North Indian Creek, which enrollees used in their free time. (Courtesy of Terry Hopson.)

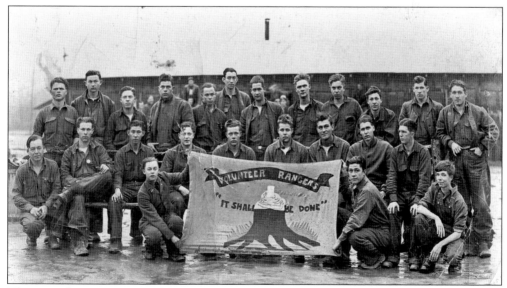

These enrollees at Camp Cordell Hull fought forest fires and manned fire towers such as Pinnacle Tower on nearby Buffalo Mountain. (Courtesy of Shirley Wilson.)

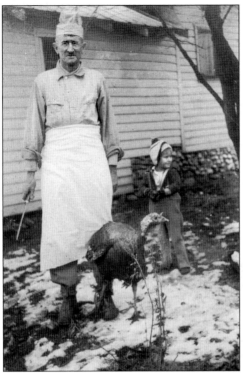

Dressed in an apron and chef's hat, Jake Hopson Sr. stands outside his home on Massachusetts Avenue in the 1930s with his granddaughter Maxie contemplating the turkey that will provide his family's Thanksgiving meal. Jake was head cook at the nearby Civilian Conservation Corp camp. His son Terry Hopson recalls his father waking him at 3:00 a.m. to help slice bread that he had baked for the camp. (Courtesy of Terry Hopson.)

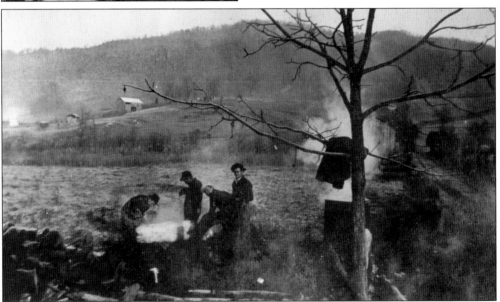

Pictured here on a cold November day around 1940, Jake Hopson's sons, (from left to right) Jay, Terry, and Ross, and an unidentified man are busy with the family's annual hog killing. They have nearly completed scraping the bristly hair from the hog after softening it with water from the steaming barrel on the right and are getting ready to gut the hog and hang it in a tree to complete the cleaning process. After cutting up the hog, the Hopson men will hang the hams and shoulders in their smokehouse to cure, and the Hopson women will render fat for lard and fry any available skin for cracklings. (Courtesy of Terry Hopson.)

During the 1930s, cows sometimes provided transportation as well as milk. Young Terry Hopson, shown here with "Old Pied" and her calf, had the job of taking the cow to graze in the grass along the railroad tracks a mile from his family's house. Terry did not want to walk that far, so he rode the cow. (Courtesy of Terry Hopson.)

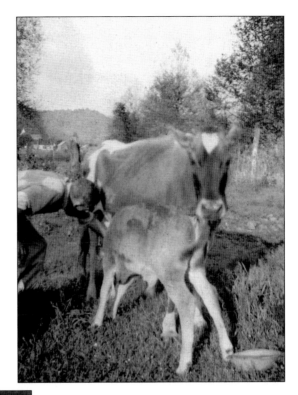

Beatrice Linville, pictured here while growing up in Unicoi, was Terry Hopson's neighbor. Later in life, when her mother, Martha Linville, was ill, Beatrice called Terry, who had become a Baptist minister, and asked him to visit Martha in the hospital. Martha was having trouble recognizing friends and family, but when Beatrice asked if she remembered Terry, Martha nodded and said, "He's the boy that rode the cow." (Courtesy of Terry Hopson.)

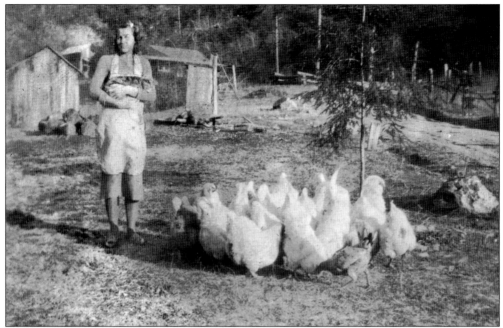

Edith Hopson White was known for her hard work and thriftiness. During the Depression, and while her husband, Alvin, was in World War II, Edith saved every penny she could and buried it in fruit jars for safekeeping. When Alvin returned from the war, Edith had saved enough money to build them a new brick home. (Courtesy of Terry Hopson.)

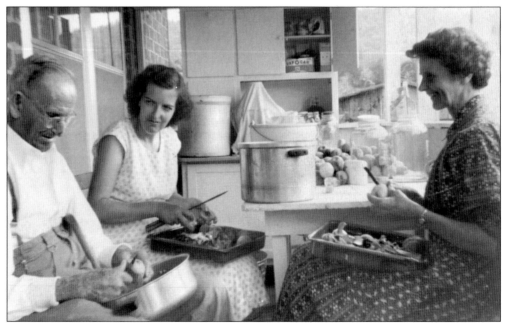

Decatur McCoury smiles as he peels peaches with Imogene (center) and Myrtle McCoury. Notice the canner and fruit jars on the table. In the 1950s, canning fruits and vegetables was a family affair in rural communities such as Unicoi. (Courtesy of Ruby Garland.)

Before the Unicoi Water Utility District formed in 1964, most Unicoi families depended on cisterns, wells, or water from the government spring off Highway 107 for their water supply. During dry weather, many families hauled water from Hoy Gouge's spring, which gushed out of a hillside on his farm. Hoy even let his neighbors cool their milk and butter in his springhouse. Here Hoy sits in his yard smoking homegrown tobacco. He was known for his abundant apple orchard, cane patch, and fall molasses boilings. (Courtesy of Terry Hopson.)

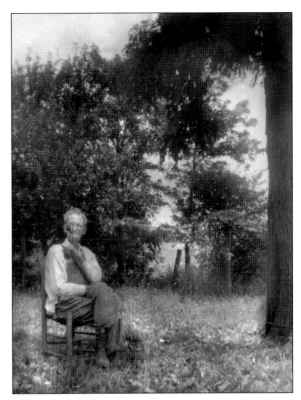

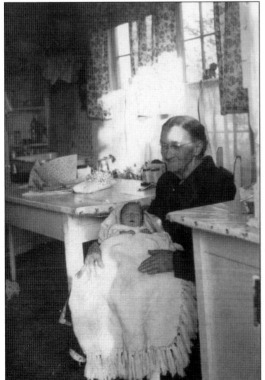

The sun shining through the kitchen window is not any brighter than Hannah Peterson's smile as she holds a precious grandchild on her lap. When this picture was taken in the 1930s, grandmothers like Hannah played important roles in helping care for babies in large families. (Courtesy of Terry Hopson.)

Pearl White, daughter of Labe and Mary White, never married and had no children of her own, but she helped mother many children in her family and was known for her kindness, generosity, and industriousness. Determined that no one who entered her parents' home would leave hungry, Pearl kept their cupboard full of cakes and pies, and their cellar full of kraut, potatoes, pickles, butter, milk, and pickled beans. (Courtesy of Shirley Wilson.)

In the 1940s, Unicoi women enjoyed gathering at one another's homes for covered-dish dinners and quilting parties. Leata Piercy is quilting a "fan" quilt rolled up on frames set up in her living room while her daughter Laurice sits at the end of the quilt frame. (Courtesy of Shirley Wilson.)

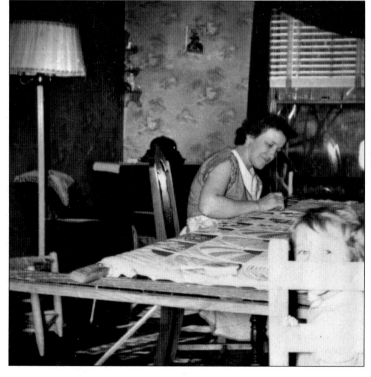

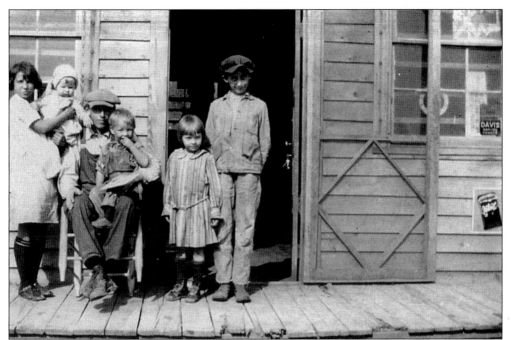

Mallie Wilson's store on the corner of Riverside Avenue and Lincoln Street had a porch where folks visited during warm weather. When it was cold, they gathered inside around a pot-bellied stove and talked with Mallie, who was known for his friendliness and great sense of humor. In this picture from the 1920s, from left to right, are Ida Moore (holding Mallie's son Charles), Mallie Wilson and son Walter, Leona Wilson, and Ernest Wilson. (Courtesy of Don Wilson.)

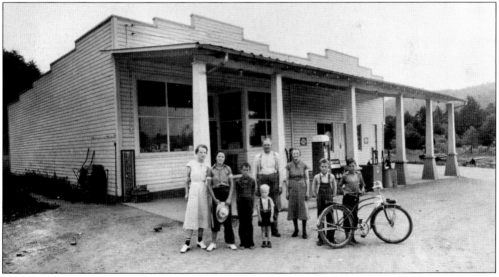

In the early 1930s, J. H. and Eddie Riddle combined two stores they operated in Unicoi to form this building. The Riddles' granddaughter Doris Wilson recalls how her grandparents had the two stores jacked up, set on log rollers, and moved to what is now Unicoi Drive. Doris was allowed to ride in one of the stores as it crossed the road. Pictured around 1938 in front of the double stores are, from left to right, Marie Peterson, Carie Peterson, David Hicks, David Bell, J. H. Riddle, Eddie Riddle, Henry McLaughlin, and an unidentified boy. (Courtesy of Doris Wilson.)

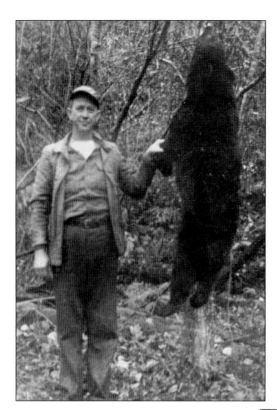

In 1947, while hunting in the Tellico Forest in East Tennessee, Edgar Howell and his brother Lester had a skirmish with the huge bear pictured here. They told the tale of their adventure for years and kept listeners on the edge of their seats while they told about the bear charging them. (Courtesy of Bob Howell.)

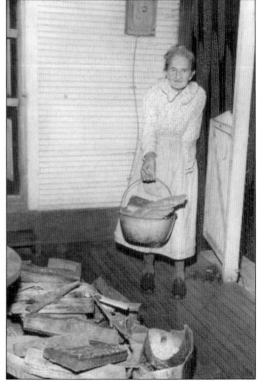

Isaac "Ike" and Lockie Gilley Street operated a store in Unicoi during the early 1900s. While working at the store, Lockie lost an arm during a holdup. Local lore recalls her saying about the robbers, "They fit me and I fit 'em back." Even with only one arm, "Aunt Lockie," as she was known, still managed to carry her firewood and tend her home, garden, and chickens. (Courtesy of Martha Erwin.)

From 1923 into the 1970s, travelers on the Dry Creek section of Highway 23 looked for George "Red" Tinker, the "man in the tree." In his free time, Red relaxed by climbing a tall tree beside the highway so he could watch traffic on the road below. Many newspapers carried stories about Red's unique way of watching the world go by. (Courtesy of Archives of Appalachia, East Tennessee State University.)

In 1958, the Jones Hardware and Supply Company opened in the building that had housed J. H. Riddle's grocery off Highway 23 in Unicoi. Owned and operated by Sam Jones Jr. and his wife, Hazel, the store was a local gathering place. In 1977, the Joneses moved their business to a new, modern building across the road from their old location. The Joneses' daughter and son-in-law, Linda and Don Plemons, purchased Jones Hardware in 1991 and are still operating it with its trademark country friendliness. This painting of the Joneses' old store is by Unicoi artist and mayor Johnny Lynch. (Courtesy of Linda Plemons.)

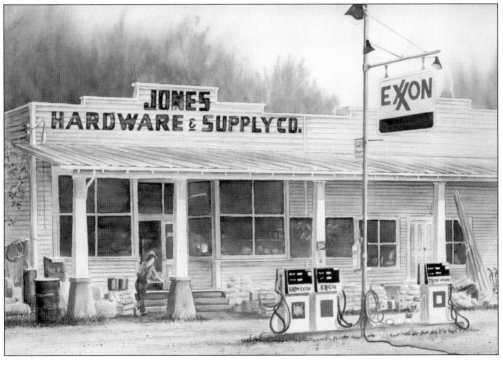

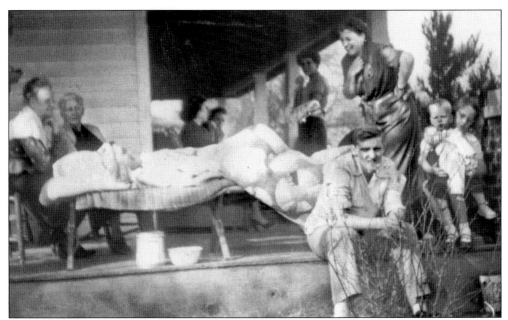

Gathered here on George Washington "Wash" Wilson's porch in 1950, friends and family are visiting with Wash's son Erful, who is recuperating from a collision with Engine No. 662, the steam locomotive pictured below. Seated on the far left is teacher Doak Bowman, and beside her is Erful's mother, Rhoda. Erful's wife, Venie, smiles as she stands at the foot of his cot. Engine No. 662 hit Erful and his son Don as they were crossing the railroad track in Erful's 1948 Chevrolet. Later the engineer admitted the crew had not sounded the whistle as the train rounded the curve that had blocked Don and Erful's view. Erful was in a body cast for seven months, but he recuperated and later moved his family to Michigan. (Both, courtesy of Don Wilson.)

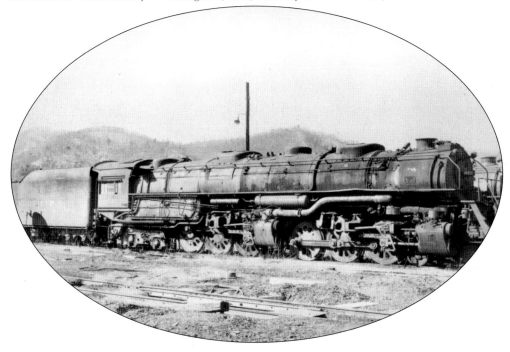

Dressed in bib overalls, David Brummett stands in his tobacco patch with his 1927 Model-A truck parked beside the road. The boy sitting on the truck is unidentified. In the 1920s, tobacco was an important cash crop for rural East Tennessee families. (Courtesy of June Elliott.)

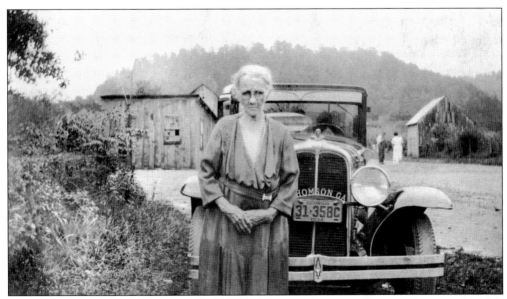

In the 1930s, George Washington "Wash" Wilson operated a gristmill across the street from his house on Lincoln Street. The mill ground corn and other grains for the neighborhood. Here the mill sits on the far left. Sara Peterson, Wash's mother-in-law, stands in the foreground in front of her grandson Nelson Wilson's 1934 Pontiac. (Courtesy of Don Wilson.)

In the 1940s, taking the Queen City bus to nearby Johnson City was an occasion to dress up and wear a hat. Henry Laws poses with Fannie Livingston (left) and Edith Tinker as they wait for the bus near Henry's store in Unicoi. (Courtesy of Edith Hawkins.)

With their gear in sacks slung over their backs, these Unicoi campers have just returned from an overnight stay on Unaka Mountain in the 1920s. They were probably picking huckleberries to bring home for jelly making. From left to right are (seated) Lee Lewis, unidentified, and Bill Norris; (standing) Everette Jones, Leata White, Susie Norris, and Lena Tinker. (Courtesy of Shirley Wilson.)

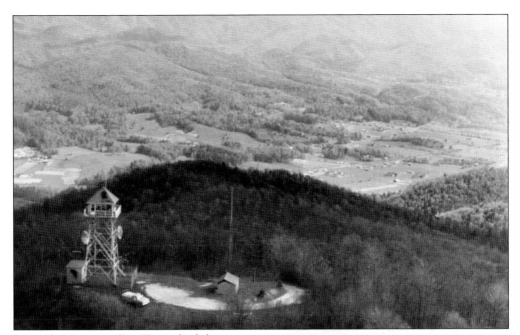

Pinnacle Mountain Fire Tower, built by the Civilian Conservation Corp for fire detection in the 1930s, was decommissioned in 1989. Located atop Buffalo Mountain, Pinnacle Tower is one of three fire towers still occupying their historic sites in the Cherokee National Forest. In 2007, the U.S. Forest Service and its partners launched efforts to rehabilitate Pinnacle Tower into a covered observation platform open to the public. (Courtesy of U.S. Forest Service, Cherokee National Forest.)

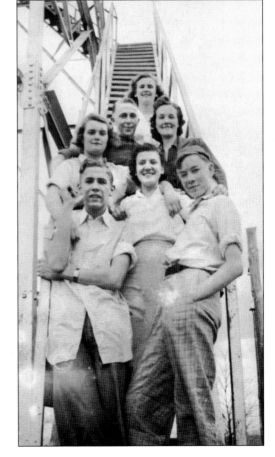

In the 1930s, Sunday afternoon was a favorite time for Unicoi's young people to walk three or more miles to Pinnacle Fire Tower on Buffalo Mountain to socialize and picnic with one another. Jack Snider (first row, left) stands with a group of his friends on the steps of the tower. (Courtesy of Edith Hawkins.)

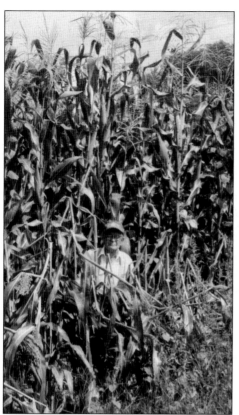

Corn grew as tall as trees in some Unicoi gardens in the late 1990s. John Piercy stands in his corn patch with the stalks towering over his head. John loved to garden when he was not working at Bemberg in Elizabethton. He and his wife, Leata, had four children: Shirley, Joel, Doug, and Laurice. (Courtesy of Shirley Wilson.)

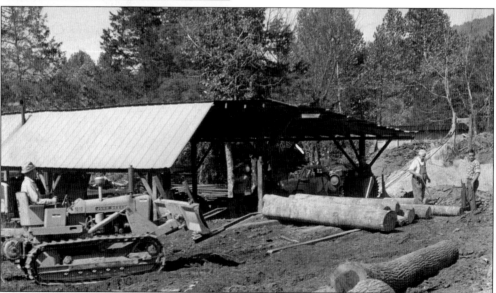

D. C. "Dee" Brummitt's sawmill, located in the "Unicoi Curve" off Highway 23, was a landmark from 1957 to 1975. Dee was an icon in the Unicoi County logging industry and was known for his friendly smile and good nature. Pictured here on the left, he is operating a bulldozer. Beyond the mill, notice the railroad trestle crossing North Indian Creek on the right. (Courtesy of Dee Brummitt.)

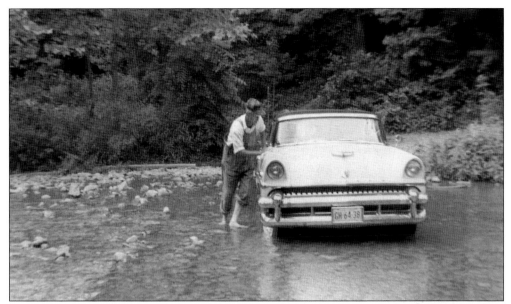

Before the advent of automated car washes, Unicoi folks like Bert White discovered that a shallow spot in the creek was a good place to wash the dust off their automobiles. With the legs of his overalls rolled up, Bert washes his nephew's car in North Indian Creek in 1956. He was the son of Solomon and Flora Smith White. (Courtesy of John Vinton White.)

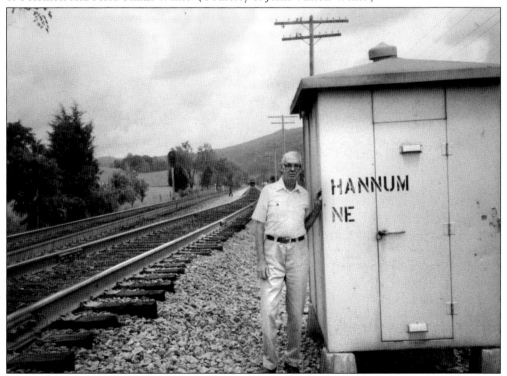

Harry Barry stands beside the railroad siding named in honor of his grandfather, early Unicoi industrialist Dr. Frank H. Hannum. The siding is located off Riverside Drive near where Dr. Hannum's Unaka Milling and Manufacturing Company once operated. (Courtesy of Beulah Barry.)

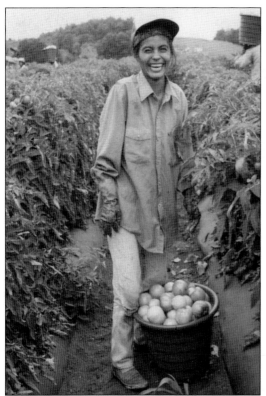

Anabel Andrade began picking tomatoes for Scott's Farms at age 13. Five years later, she began work as a teacher's aid, serving children of migrant workers for Telamon Corporation in Unicoi. Later Anabel worked as an office assistant at Telamon before assuming her current position as a health and disability specialist. She is also pursuing a bachelor's degree in early childhood education at East Tennessee State University. (Courtesy of Anabel Andrade.)

Zenaida Saldana and Serafin Acevedo were among the early Hispanics to work at Scott's Farms in Unicoi. Zenaida cooked for the migrant crews for 24 years beginning in 1982. Serafin picked strawberries and tomatoes before becoming a driver, hauling the workers to the fields. He also had the responsibility of seeing that the strawberries and tomatoes were picked properly. (Courtesy of Anabel Andrade.)

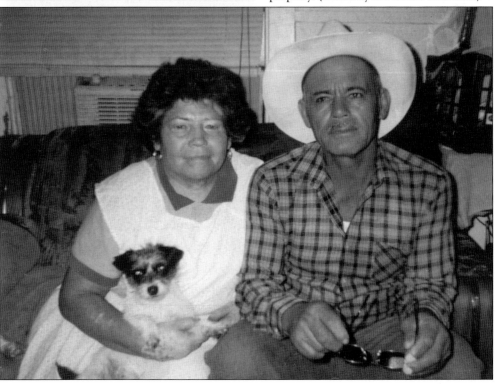

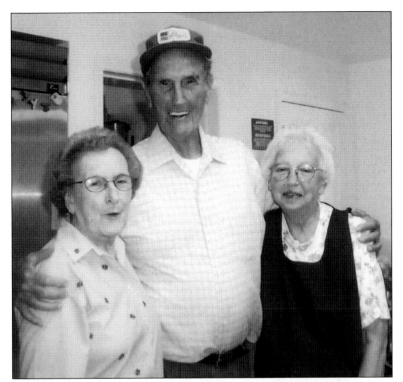

Wayne Scott (center) was a founding member of Unicoi Ruritan, which was chartered in 1949. Hazel Berry (left) and Hazel Tittle share a hug with Scott at the Ruritan's preserve-making in 2006. For many years, Wayne donated strawberries grown on Scott's Farms for the Unicoi Ruritan's strawberry preserve-making. (Courtesy of the author.)

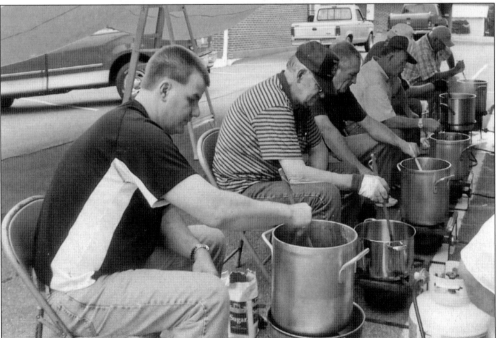

Each spring, the Unicoi Ruritan Club's major fund-raising project is making and selling thousands of pints of strawberry preserves. From left to right, Jamie Hopson, Gene Miller, Norman O'Dell, Dr. James Ray, Don Wilson, and Jerry Ramsey stir pots of the hot preserves over propane burners in 2006. (Courtesy of the author.)

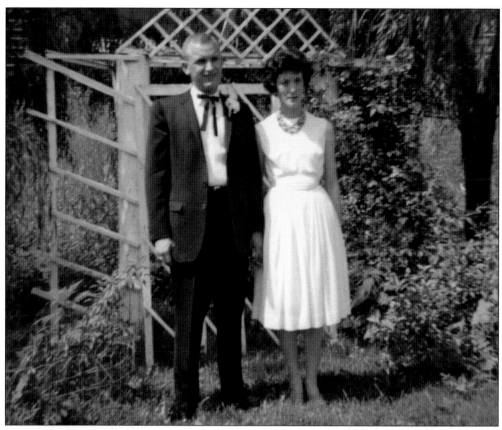

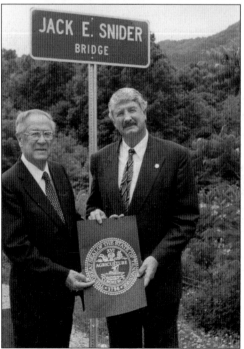

Pictured above in 1961, Don and Sharlyne Wilson have just said their wedding vows. In the Unicoi community, the Wilsons are known for their generosity and neighborliness. In 2007, Don received the Service to Community Award, given by the *Erwin Record*. His fellow Unicoi citizens nominated him because of his extraordinary willingness to help individuals and organizations in need of assistance. (Courtesy of Don Wilson.)

From 1978 to 2002, Unicoi resident Zane Whitson Jr. (right) served as the state representative for Unicoi and Greene Counties. Among his achievements, many consider the construction of Interstate 26 from Unicoi County to North Carolina to be his greatest. Whitson was also a respected coach and educator in the Unicoi County school system. Here he is honoring prominent Unicoi native Jack Snider, for whom this bridge on Highway 181 was named. (Courtesy of Jack Snider.)

Four

WORK, PLAY, COMMUNITY
LIMESTONE COVE

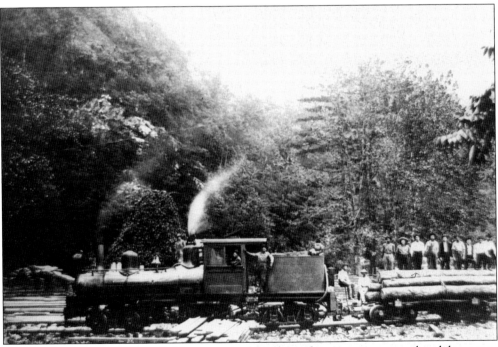

Chartered in 1905 by William E. Uptegrove and Brothers, this narrow-gauge railroad, known as the Johnson City, Bakersville, and Southern Railway, ran from Unicoi to Limestone Cove and Unaka Mountain. Pictured here is one of the little trains used in the early 1900s to climb the narrow-gauge tracks built on the rough mountain terrain. Jack Schultz, standing behind the logs third from left, supervised the building of the trestles needed to cross the ravines. Later Schultz drove the trains. (Courtesy of Janice Crall.)

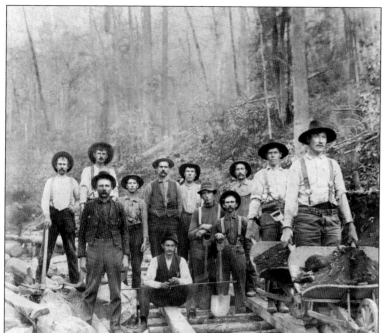

Hauling timber off Unaka Mountain required building rail spurs into the woods. Often these narrow-gauge spurs, winding across steep hillsides and over ravines, were constructed of wood, as pictured here. Laborers dug the track bed with picks and shovels, and hauled the dirt away in wheelbarrows with wooden wheels. (Courtesy of Chuck McInturff.)

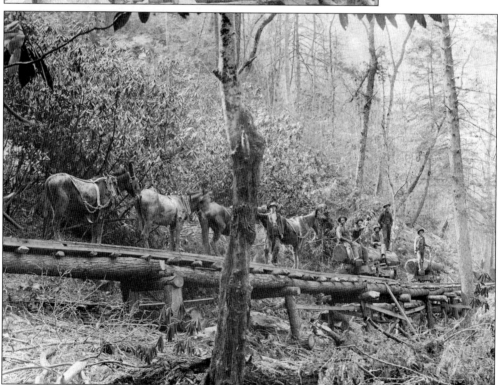

Timber operators built tram roads into the dense laurel thickets on Unaka Mountain in order to access certain types of trees. The wooden rails of this tram road rest on a low trestle that spans the uneven terrain. Notice the mules and horses used to pull the railcars loaded with logs. (Courtesy of Chuck McInturff.)

The Unaka Mountain timber operations required constructing railway inclines such as this one up the steep mountainsides. The tiny building pictured at the head of the incline is the same building shown in the picture below, even though the curve at the top of the incline is not apparent from this perspective. Notice the cable pulley at the end of the rails pictured here. Cables were used to pull loads of lumber up steep inclines and to lower loads of lumber down them. (Courtesy of Archives of Appalachia, East Tennessee State University.)

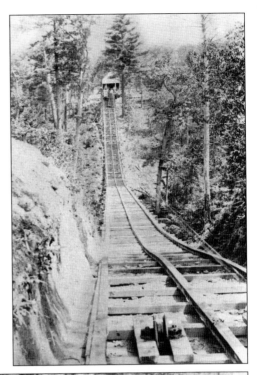

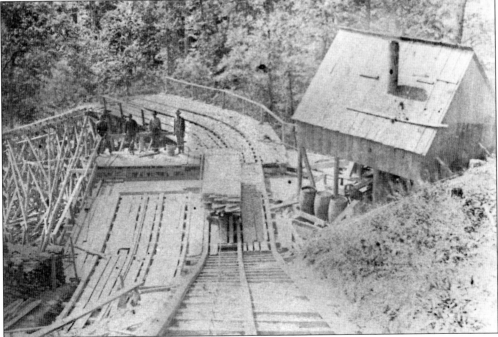

This shed housed a steam engine generating the power needed to pull cables that acted as a braking or hoisting device in the descent and ascent of railcars loaded with lumber. Notice the water barrels beneath the shed and the wooden trestle spanning the ravine on the left. The barrels held water that was used by the steam engine to generate the power to pull the cables. (Courtesy of Archives of Appalachia, East Tennessee State University.)

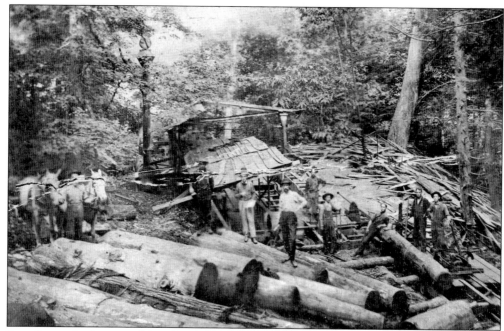

Standing in the foreground, hand on his hip, is Henry Davis, the Limestone Cove timber operator and owner of Red Fork Mill on Unaka Mountain in the early 1900s. To Henry's left stands his son Frank, and the horses are Polly and Molly. Molly once helped Henry outrun a band of robbers, and she also pulled the hack that carried the Davis family to church. (Courtesy of Jack Davis.)

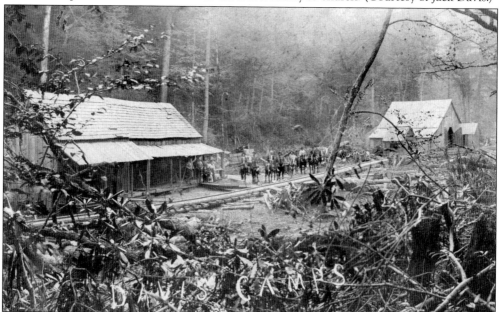

In the early 1900s, Henry Davis established Davis Camps to house workers employed in his extensive timber operations. Henry's mills supplied lumber for the J. Walter Wright Lumber Company. During World War I, the mills provided spruce to make ship keels for the navy. At one time, Henry owned around 7,000 acres of timberland in Limestone Cove and on Unaka Mountain. (Courtesy of Jack Davis.)

Pictured here around 1916 are, from left to right, Bill Tuttle, Mendal Birchfield, Will Frye, Zeke Birchfield, and D. W. Buchanan. They are examining the spot where a tree branch fell and wounded Isaac Birchfield while he was working. In the early 1900s, Isaac was a timber estimator for Clear Fork Lumber Company and William E. Uptegrove's lumber operations on Unaka Mountain. Isaac recovered from the accident. (Courtesy of Tom Gouge.)

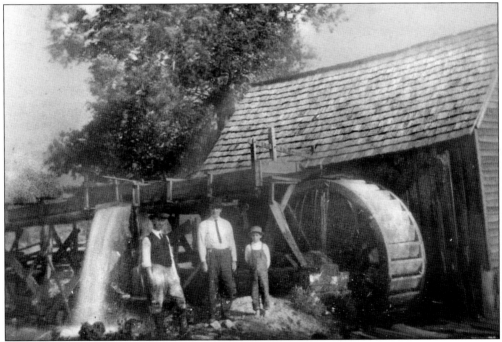

In the early 1900s, Dosser Buchanan owned this gristmill, located off present-day Sunshine Lane in Limestone Cove. Sarah Gouge ran the mill while Dosser owned it. Notice the huge water wheel and the water pouring from the millrace. Pictured here around 1916 are, from left to right, Dr. ? Howell, Bill Tuttle, and Mendal Birchfield. (Courtesy of Tom Gouge.)

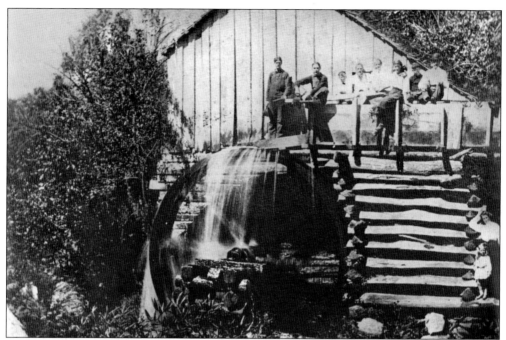

Dr. Daniel Schultz's gristmill off Iron Mountain Road was a testimony to his ingenuity. He cut and calibrated the mill's huge grinding stones and constructed the large waterwheel. Dr. Schultz was also a furniture maker, blacksmith, and gunsmith. Members of the Schultz family and members of the community are gathered at the mill around 1908. (Courtesy of Janice Crall.)

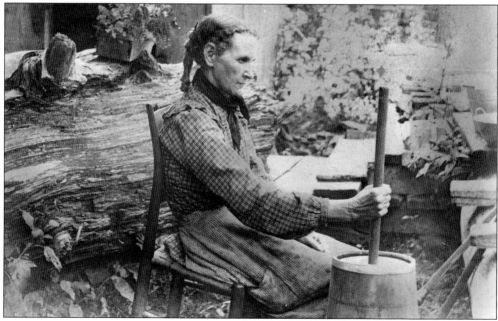

Mary Jane "Polly" Sutton Schultz looks thoughtful as she sits churning butter in her wooden churn, possibly made by her husband, Dr. Daniel Schultz. Polly married Dr. Schultz around 1874. Their children were Eliza, Mary Lee, Jack, Nancy, Lewis, David, George, Addie, and Nellie. (Courtesy of Janice Crall.)

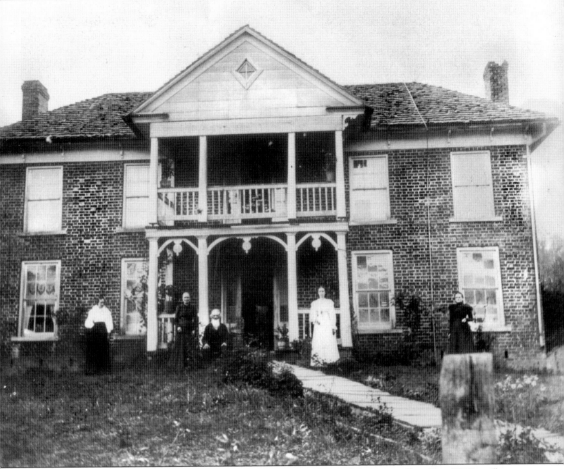

The Ezekiel and Sallie Birchfield house, built off Upper Stone Mountain Road in 1878, reflects the family's prosperity as well as its resourcefulness and hard work. Constructed mostly from materials (including the clay for the bricks) found on the surrounding property, the house had a fireplace in every room, and the walls were four bricks wide. In addition to raising corn, wheat, and other produce, Ezekiel and his sons operated a dry kiln used for drying fruit, a tannery, and a government distillery that produced corn whiskey and apple brandy. The distillery consisted of two copper stills that stood in a shed with water for the distilling coming from nearby spring water routed through a trough hewn from poplar logs. Pictured here in the early 1900s, Ezekiel sits in the yard near the door. (Courtesy of Tom Gouge.)

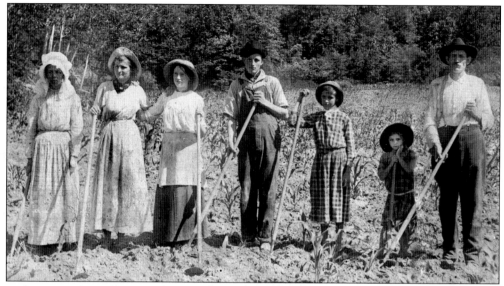

In the early 1900s, photographers traveled through the mountains taking pictures that they then printed on postcards. In this real-photo postcard, taken on June 24, 1916, Sarah Sneyd's family stands lined up with their hoes in a cornfield. Notice the smallest girl's tiny hoe and the family members' individual taste in hats. (Courtesy of Max Simerly.)

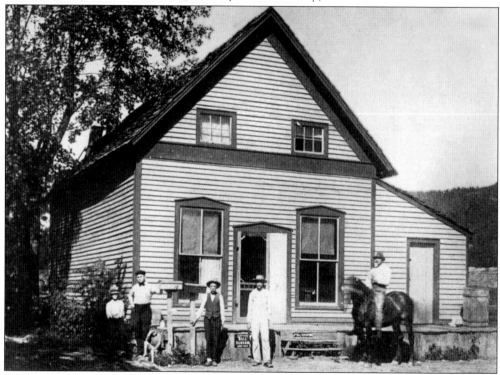

In the early 1900s, Dosser Buchanan's store also served as the Limestone Cove Post Office. Notice the two tall mailboxes to the left. The mail carrier opened their lids with a stick while still on horseback. Dosser served two terms as Limestone Cove's postmaster and 32 years as a mail carrier. He also built his store. Notice the store's attractive window and door framing. (Courtesy of Tom Gouge.)

Many older Limestone Cove residents have fond memories of riding the Queen City Bus with driver Ike Davis (left). The Queen City Bus line ran through Unicoi and Limestone Cove in the 1940s. Pictured in his Queen City uniform, Ike sits beside Isaac Birchfield. (Courtesy of Tom Gouge.)

In the early 1900s, Wilson McKinney and other Sinking Creek men belonged to the civic-minded International Order of Odd Fellows. The Odd Fellows, pictured here, met at Swanner Cemetery on Fiddler's Branch Road. (Courtesy of Max Simerly.)

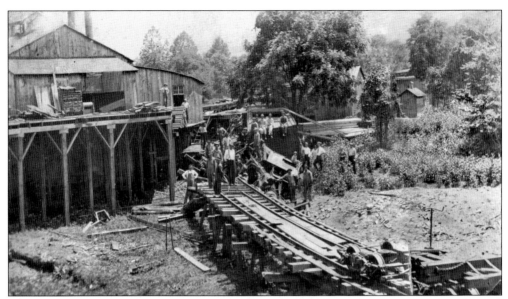

This lumber mill sat at Furnace Flats in Limestone Cove in the early 1900s. Here men (center) stand around the wreckage of one of the narrow-gauge trains that hauled logs from the timber operations on Unaka Mountain. The accident killed lumberman John Booth. (Courtesy of Chuck McInturff.)

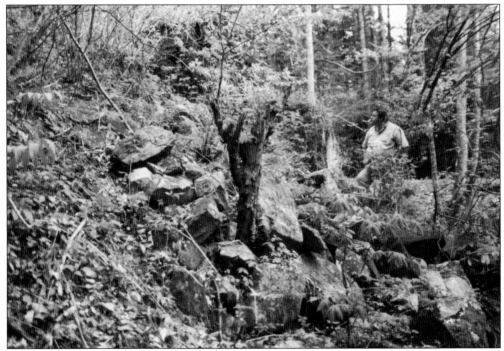

Swingle's Iron Works operated a furnace and nailery at Furnace Flats as early as 1803, according to census and court records. Bob Howell views the remains of an old iron furnace at Furnace Flats off George Stanley Road in Limestone Cove. (Courtesy of Furman Bryant.)

Elijah and Arra McKinney's home served for 50 years as the Watauga Regional Library System's circulation center on Simerly Creek. Arra was the librarian, and later, her daughter Lena held the position. On bookmobile day, Lena served a meal with plenty of desserts. Community members would drop by to eat Lena's cooking and check out new books. Arra and Lena's library received many awards for highest circulation in the Watauga region during its service to the community, beginning in the 1940s and continuing until the late 1990s. (Courtesy of Max Simerly.)

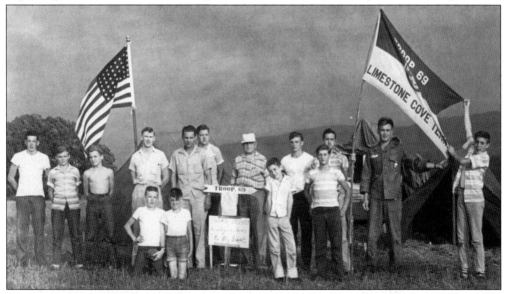

The Limestone Cove Methodist Church held the charter for Boy Scout Troop 69 from 1952 to 1968. From left to right, the group includes (first row) Elwood Simerly, Sam Berry, and two unidentified; (second row) Bobby McKinney, Richard Marcus, unidentified, John Marcus, Jack Berry, Rex Simerly, three unidentified, Ben Gouge, and Gene Clark. (Courtesy of Max Simerly.)

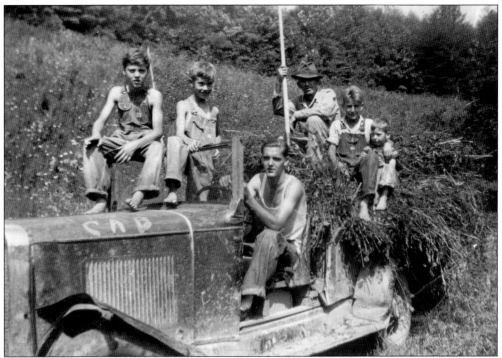

Putting up hay was a family affair for the Simerly and McKinney families on Simerly Creek. In this 1941 photograph, Carson Simerly drives the truck while (from left to right) Butch Simerly, Burl Berry, Wilson McKinney, Bruce McKinney, and Norman Simerly go along for the ride. Notice the smiles on the boys' faces. (Courtesy of Max Simerly.)

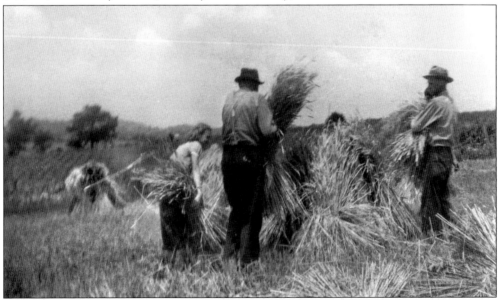

In this delightful Limestone Cove farm scene from the early 1950s, the Hixon and Campbell families harvest wheat. Notice the unidentified young girl on the left with her pant legs rolled up. Beside her is Coy Hixon, and to the far right is James Campbell with a sheaf of wheat in one arm and a little boy in the other. (Courtesy of Geraldine Love.)

Pierce N. Garland (far right) was Limestone Cove's mail carrier for 38 years. In the beginning, he delivered the mail on horseback, using one horse for the morning route and another for the afternoon. He is remembered not only as a mailman, but as a friend and counselor to the people he served. As he collected and delivered the mail, Pierce also collected food, clothing, and other necessities from those who could share and delivered them to those in need. (Courtesy of E. Harold Burleson.)

Born in 1917 as the son of Pierce and Eva Brooks Garland, Judge Walter Garland left a distinguished legacy as a judge and historian. In 1960, he was elected the Unicoi County General Session Court judge, and in 1966, he became the circuit court judge for the 1st Judicial District. Judge Garland was instrumental in helping create the Unicoi County Historical Society in 1971 and also served as its first president. (Courtesy of Kent Garland.)

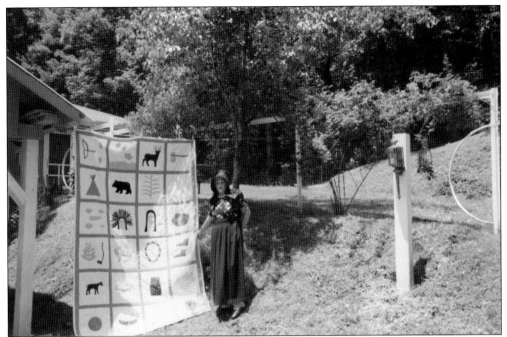

Tom and Nadine Gouge love history, especially East Tennessee history. Above, Nadine, wearing her pioneer bonnet and skirt, stands beside a quilt she made to commemorate the area's Native American heritage. Below, Tom stands beside the log barn, built in 1939, where his mother Daisy Birchfield Gouge and his sisters once milked the family cow. Tom's ancestry in Limestone Cove goes back to Revolutionary War veteran Nathaniel Birchfield. (Both, courtesy of Tom and Nadine Gouge.)

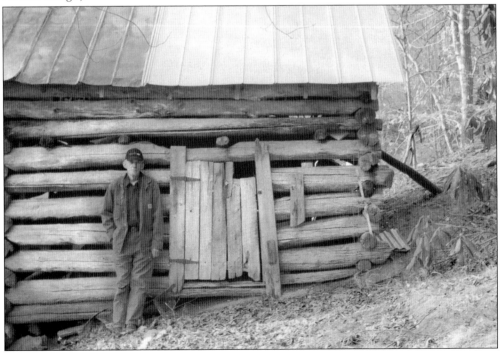

Five
EDUCATION AND
RELIGIOUS LIFE
UNICOI

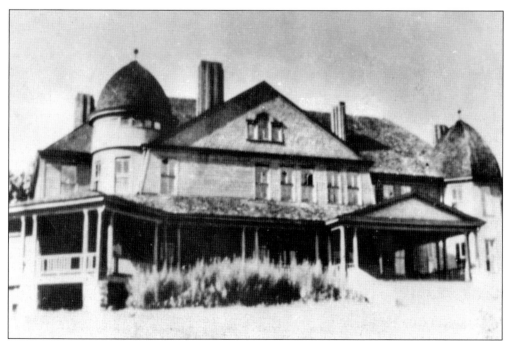

In 1892, the Unicoi Development Company contracted with McDaniels and Stone from Chattanooga to build this grand hotel—the central landmark of early Unicoi. In the early 1900s, the hotel served as a Free Will Baptist school and then as a Unicoi County public school before burning in 1935. (Courtesy of Edith Hawkins.)

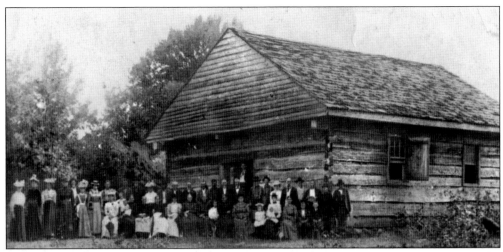

During the mid-to-late 1800s, the old Jones log schoolhouse—named for early Unicoi settler Solomon Hendrix Jones—served as a school as well as the meeting place for Unicoi's first Methodist congregation. Pictured here in the summer of 1889, the congregation is having a reunion at their old church on the banks of North Indian Creek. (Courtesy of Archives of Appalachia, East Tennessee State University.)

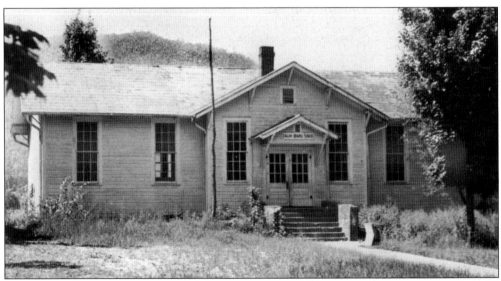

Located on Whispering Pines Road, the Fagan Chapel took its name from early Unicoi settler W. R. Fagan. In 1924, fifty-one students were enrolled at the Fagan Chapel for the school year, which lasted 120 days. The Fagan Chapel consolidated with the Unicoi School in 1950. (Courtesy of Nancy Gentry.)

With their shirtsleeves rolled up and shoes off, these students at Dry Creek School in the early 1920s are enjoying a warm day. From left to right are (seated) Earl Tinker, Marsh Miller, Paul Luttrell, Leata White, Ralph Tinker, and Willard McInturff; (standing) an unidentified teacher, Ralph Luttrell, Elbert Miller, Orville McInturff, and Bert McInturff. (Courtesy of Chuck McInturff.)

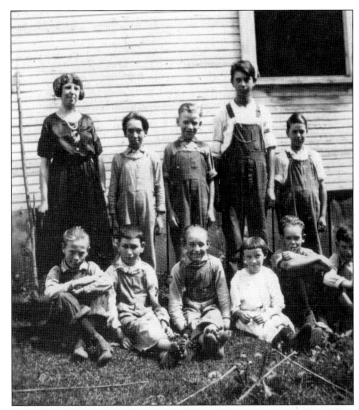

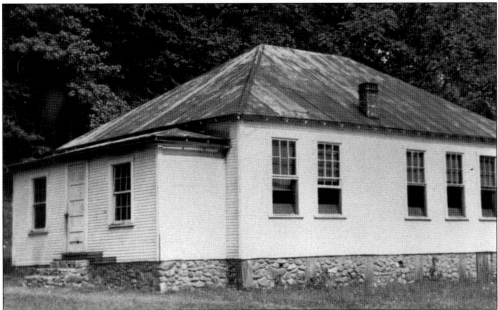

In 1924, the Dry Creek School, located at the intersection of Dry Creek Road and the Clinchfield Railroad tracks, had an enrollment of 36 students for 120 school days. Records list Nola Banks as the teacher. The Dry Creek consolidated with the Unicoi School in 1940. (Courtesy of Nancy Gentry.)

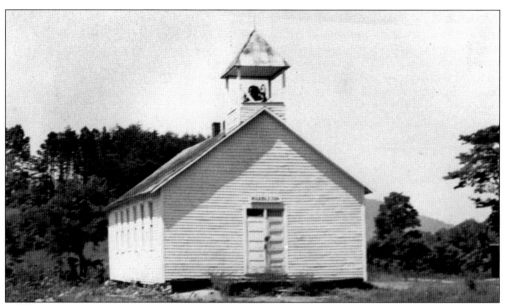

Built in the 1920s where the present-day Marbleton Community Center sits, the Marbleton School was the typical small, rural school capped by a steeple-shaped belfry and bell. In 1927, sixty students were enrolled for 160 days. The Marbleton School consolidated with the Unicoi Elementary School in 1957. (Courtesy of Nancy Gentry.)

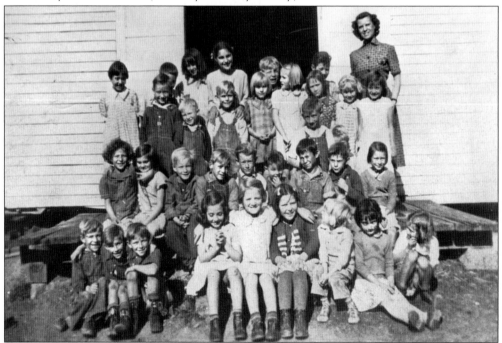

Marbleton was a two-teacher school in the mid-1930s when young Alma Sutphin (standing, fourth row, far right) taught the first, second, and third graders. During the big snow of March 17, 1936, Clarence McInturff used his horse to clear a path for Alma and fellow teacher Callie Guinn to get to school, but the snow was so deep that they could not open the door. Instead, Alma and Callie climbed in a window and taught the few students who showed up. (Courtesy of Alma Cates.)

At age 65, in 1943, Doak Wilcox Bowman received her bachelor's degree from East Tennessee State College. Descended from and named for early East Tennessee educator Samuel Doak, Mrs. Bowman left a rich legacy at Unicoi Elementary, where she taught first grade for 19 years. In 1985, the Unicoi County Retired Teachers Association named her as one of nine county women who had been most influential in the growth of the area. (Courtesy of Pirkko McNabb.)

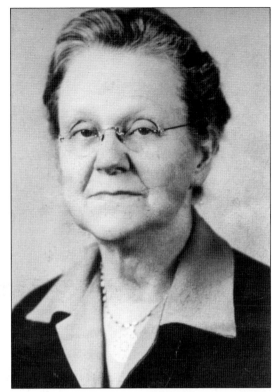

Set amidst tall trees near where the U.S. Forest Service office currently sits, teacher Doak Bowman's spacious clapboard house had three levels accessed by rambling staircases. Col. Talmadge McNabb described it as looking like "something from a story book." Pictured below in the 1980s, a few years after her death, Mrs. Bowman's once-immaculate house and grounds reflect her absence. (Courtesy of Pirkko McNabb.)

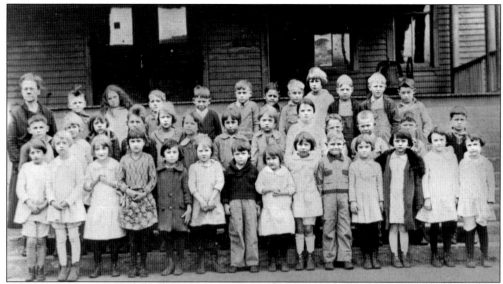

In 1978, Col. Talmadge McNabb wrote in the *Erwin Record* concerning his first grade teacher, Doak Bowman: "She has made richer those lives, which have touched her own." In this 1930 photograph, Talmadge is the student third from left on the third row. Behind Bowman and the students stands the old Unicoi Hotel, which then served as a public school. (Courtesy of Shirley Wilson.)

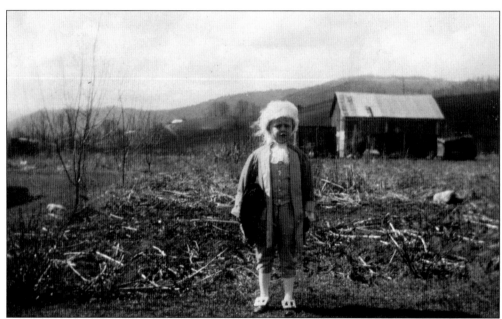

Each year, Doak Bowman's first-grade class performed patriotic and seasonal plays, and many of her former students still recall their roles. In 1938, Billy Lee Wilson starred as Gen. George Washington. Notice Billy's costume—complete with powdered wig and buckled shoes—as he poses in his Unicoi backyard. Neighbor Nat Linville's molasses boiling shed stands in the background. (Courtesy of Billie Lee Wilson.)

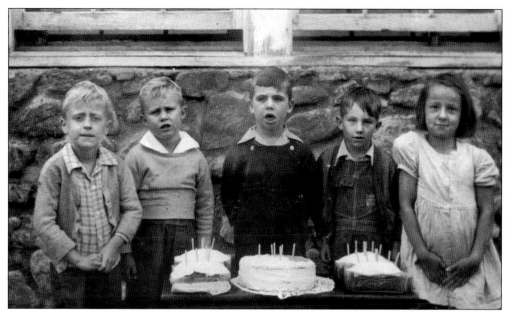

Doak Bowman wanted fellow teacher Ethel Howell to name her first child "Thankey" because he was born on Thanksgiving Day. Ethel named her son Robert instead, but Bowman still called him Thankey. Pictured in 1945, Thankey celebrates his birthday with other first graders in Doak Bowman's class. From left to right are Bobby Roberts, Herman Booker, Bob "Thankey" Howell, Jack Hicks, and Sarah Britt. (Courtesy of Bob Howell.)

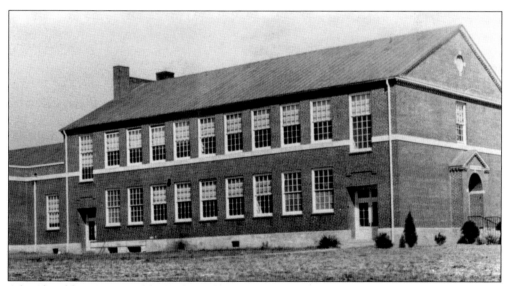

After the old Unicoi Hotel burned in February 1935, school was held in Dr. C. N. Wilcox's office on Tennessee Street and in various churches in Unicoi. In 1936, Unicoi students happily began attending classes in this newly constructed redbrick school building on Massachusetts Avenue, near where the hotel had stood. (Courtesy of Nancy Gentry.)

These children were called the "block babies" because, in 1957, they were born to families all living on the same block in Unicoi. Throughout their childhood, they posed for pictures to commemorate significant transitions in their lives. In the above photograph, they are infants, and in the picture below, they are entering first grade at Unicoi Elementary (with principal Claude White holding his head in mock dismay). In both pictures, mothers and children are positioned in the same order. From left to right are (seated) Shirley and Kim Wilson, Hazel and Tim Jones, Hazel and Diane Berry, and Madeline and Benjamin Barnett; (standing) Marie and David Ramsey, Sheila and Teresa Jones, Edith and Becky Hopson, Dot and Linda Blevins, and Marie and Angela McLaughlin. (Both, courtesy of Shirley Wilson.)

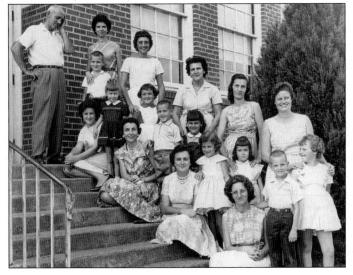

Unicoi Elementary's 1940s graduates are still a tightly knit group. Many have lived in other parts of the country but have returned to Unicoi and the surrounding area for retirement. Each summer, members of the group gather for a reunion dinner and share heartwarming and humorous stories about their many adventures and misadventures while growing up in Unicoi during the 1930s and 1940s. Above, the group gathers for a picture after their 1996 reunion. Group members do not wait for the annual reunion to meet, however—they meet monthly if possible. Below, (from left to right) Arlene Bailey McFall, Jean Whitson Lyle, Edith Wallen Edwards, Shirley Piercy Wilson, and Eula Linville Tipton are enjoying one of these impromptu get-togethers. (Above, courtesy of Speedy Hopson; below, courtesy of Shirley Wilson.)

In this painting, Unicoi artist Urban Bird has captured the simplicity and beauty of the Jones Chapel Church, dedicated in 1889 by the congregation that had previously met in the old Jones log schoolhouse. The chapel's bell rang over the village of Unicoi, calling church members to worship, and at funerals it tolled once for each year of the deceased person's life. The Reverend Frank Little was the church's first pastor. (Courtesy of Howard Street.)

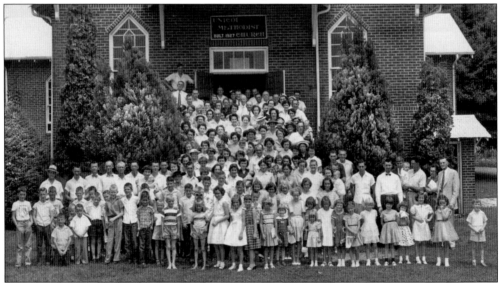

The congregation that once met in the Jones Chapel Church on the hill moved into a new church, the Unicoi United Methodist Church, in 1927. The men donated much of the labor needed to build the church, and the women raised funds by piecing and selling quilts, and holding ice cream and poke suppers. Poke suppers were church benefits where meals prepared by young women were placed in paper bags and auctioned off to the highest bidder—usually the girl's sweetheart. In the summer of 1954, congregation members, young and old alike, gathered in front of the church for this picture. (Courtesy of Edith Hawkins.)

In this drawing, artist Harvey Howell captures the charm of the old Unicoi Church of Christ (erected in 1893). Notice the belfry tower on the right. Early Unicoi businessman R. S. Chevis was instrumental in the building of this church, which today's Unicoi Christian Church replaced. (Courtesy of Howard Street.)

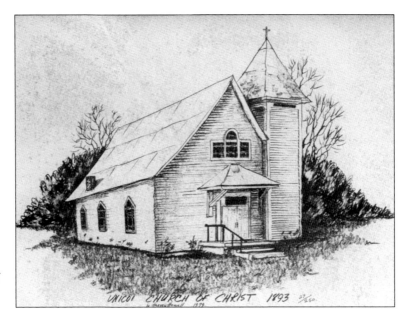

Completed in 1932, the Unicoi Church of God's rock church is a testament to the hard work and spirit of its congregation. Most early members were women. Their husbands hauled rock from North Indian Creek to build this church on Tennessee Street, which replaced the house on Lee Street where they had been meeting. In 1974, the congregation dismantled the old rock building and built a new brick church, where descendants of early members still worship. (Courtesy of Ferne Bradley.)

This 1930s picture shows the Unicoi Baptist Church. Church members laid the cornerstone for Unicoi Baptist in 1929. The men hauled the rock for the church from area streams, and the women sold quilts and chickens for the building fund. Frank Edwards and Bert White did the masonry work. The new church held its first meeting on February 7, 1932. Rev. J. C. Sherwood preached the first sermon. The first deacons were D. W. Buchanan, R. N. McInturff, and W. A. Sams. (Courtesy of Isabel Jones.)

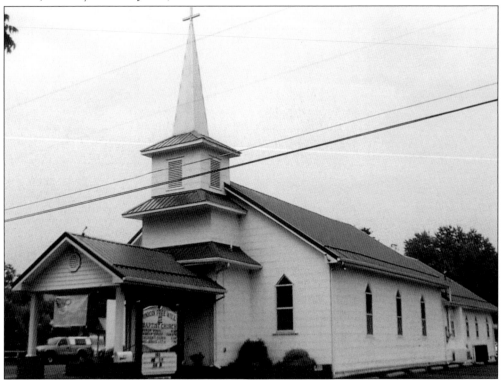

Minutes from the Jack's Creek Free Will Baptist Association mention a Free Will Baptist congregation existing in Unicoi as early as 1924. Sometime after this, George Washington "Wash" Wilson donated the land for, and helped construct, the Unicoi Free Will Baptist Church. Some older members have attended today's Unicoi Freewill Baptist Church for more than 60 years. (Courtesy of the author.)

Six

EDUCATION AND
RELIGIOUS LIFE
LIMESTONE COVE

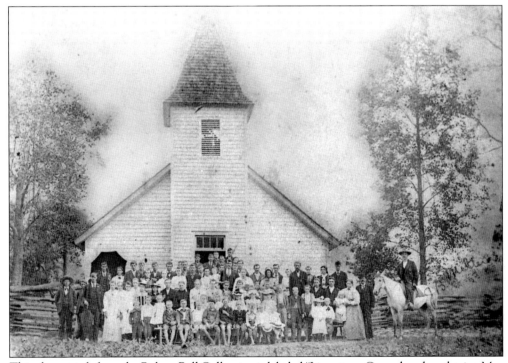

This photograph from the Robert Bell Collection is labeled "Limestone Cove church gathering May 1898." Older Limestone Cove residents have identified the building as the Limestone Cove Christian Church, which was constructed on land that Dr. David J. N. Ervin deeded to Ezekiel Birchfield Sr. in 1895. Ezekiel provided the lumber to build the church and his son Ezekiel Jr. did much of the construction work. (Courtesy of Archives of Appalachia, East Tennessee State University.)

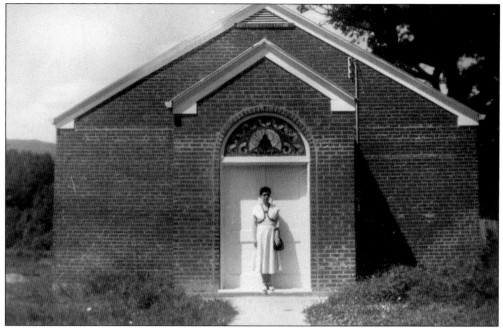

Ruth Masters stands in front of the brick chapel built to replace the original frame Limestone Cove Christian Church (pictured below) that burned around 1949. Rev. Henry Webb and Rev. Paul Nourse led the revival that culminated in the dedication of the new brick building in 1952. In 1954, electric heaters replaced the old coal stoves, and today's structure is topped with a tall steeple. (Courtesy of Geraldine Love.)

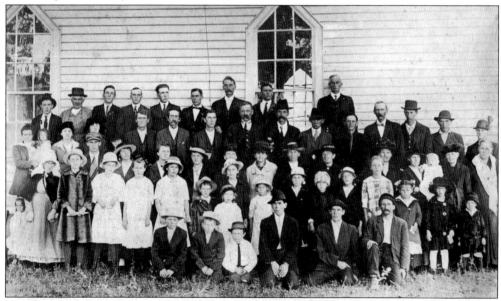

On August 14, 1920, the congregation of the Limestone Cove Christian Church gathered for this picture. At the time, the Missionary Baptist congregation had been meeting with the Christian congregation since 1915. The church history from 1920 notes that Mrs. Bill Birchfield (third row, far right, wearing the white shawl) prepared the Lord's Supper every Sunday. (Courtesy of Hattie Bell.)

Henry Davis's son Frank (fifth from left) served many years as the superintendent of the old Methodist church that became the Memorial Union Church in Limestone Cove. Here Henry's sons Eorge (second from left) and Jerome (far right) and other members of the Davis family surround Frank. Henry donated the lumber to build the Methodist church in the early 1900s. (Courtesy of Tom Gouge.)

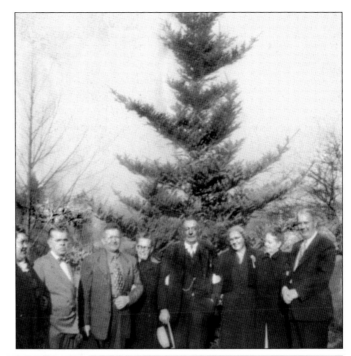

Venie Buchanan (fourth from left) participated in this Limestone Cove singing school led by Doc Davis around 1912. Singing schools not only provided opportunities to improve one's voice and learn new songs, but also provided all ages with the chance to socialize. Notice the decorative hats on the young ladies pictured here. (Courtesy of Brenda Brinkley.)

In 1952, nine families from the congregation that met at the Limestone Cove Memorial Union Church decided to form their own Methodist congregation. This new congregation met in the old Elisha Garland house until 1953, when they moved into the building pictured here. Pierce Garland donated the land, and George Bell contributed much of the timber used to construct the new church. (Courtesy of the author.)

On Mother's Day, 1967, the Limestone Cove Memorial Union Church acknowledged Venie Greene as the oldest mother present and honored her with flowers. From left to right are Norma Clark, ? Bromwell, Grace Gouge, Bertha Davis, Louise Bromwell, Nora Davis, Venie Greene, Marie Greene, and Mardell Greene. (Courtesy of Norma Clark.)

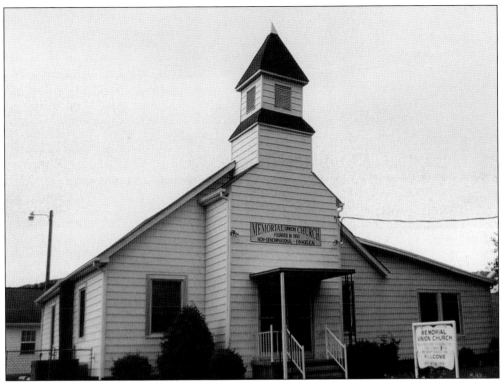

In the early 1940s, when the frame Limestone Cove Elementary School building (below) burned, students had class in the Limestone Cove Memorial Union Church (above). Students met in the sanctuary and two other rooms in the church, all heated by pot-bellied stoves, until completion of a new brick school around 1948. In 1969, Limestone Cove Elementary students began attending Unicoi Elementary School as a result of consolidation of the two schools by the county school board. (Above, courtesy of the author; below, courtesy of Nancy Gentry.)

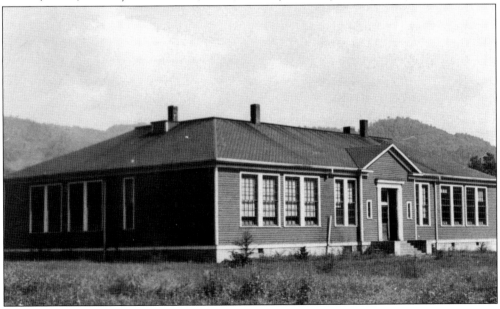

In this 1941 photograph, driver John Marcus poses with the bus that carried Limestone Cove and Unicoi students to high school in Erwin. (Courtesy of John Marcus.)

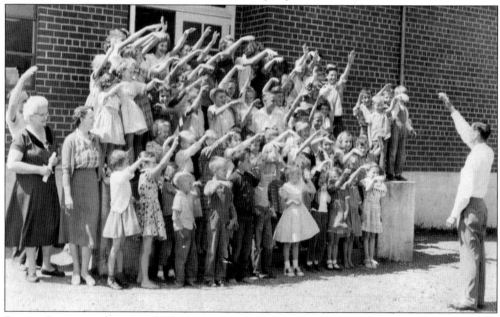

Roscoe Greene taught in Mitchell County, North Carolina, and in several Unicoi County schools during his 50-year teaching career. Here in 1958, he waves goodbye to Limestone Cove students and faculty after retiring as the school's principal. On the first row are teachers Elizabeth Early (far left) and Alice Buchanan (second from left). (Courtesy of Marie Greene.)

Seven

WAR AND PEACE
UNICOI AND LIMESTONE COVE

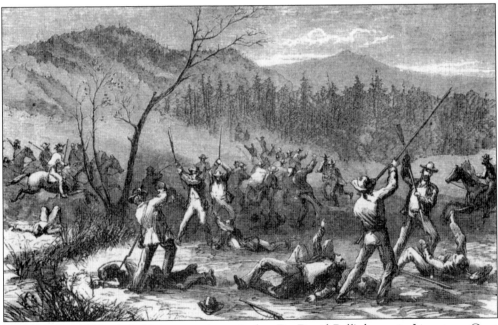

In November 1863, while Union recruits waited at Dr. David Bell's home in Limestone Cove for scout Daniel Ellis to arrive and escort them to the Union army in Kentucky, Confederate soldiers from Col. W. A. Witcher's cavalry suddenly attacked. The bloody massacre of Unionists that followed is depicted in this woodcut from *Thrilling Adventures of Daniel Ellis* by Daniel Ellis, published by Harper and Brothers in 1867. (Courtesy of Overmountain Press.)

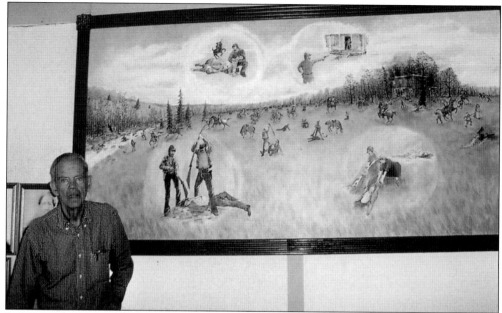

Jack Davis stands in front of a mural by artist Harvey Howell depicting the Bell Massacre of 1863. In 2009, Jack began work on a heritage center at Davis Springs to preserve some of his family's and Limestone Cove's history. During the early 1900s, Jack's grandfather Henry Davis ran a large timber operation and owned around 7,000 acres of land in Limestone Cove. Henry also hosted annual singing conventions at Davis Springs. The heritage center plans to revive the singing conventions and possibly host reenactments of the Bell Massacre. (Courtesy of the author.)

James Samuel McInturff was the son of Unicoi pioneer John "Crowner" McInturff. During the Civil War, Sam fought for the Union as part of the 8th Tennessee Cavalry. Family lore recounts that after being discharged in 1865, Sam walked from South Carolina back home to Tennessee. Though blinded during the war, Sam later regained his sight. (Courtesy of Chuck McInturff.)

This picture was taken following Frank H. Hannum's graduation from the Virginia Military Institute in 1856. He later graduated from medical school. During the Civil War, Dr. Hannum served in several Confederate units, including the 61st Tennessee Cavalry, where he attained the rank of second lieutenant. In 1865, he was discharged from a military prison on Johnson's Island, Lake Erie. (Courtesy of Beulah Barry.)

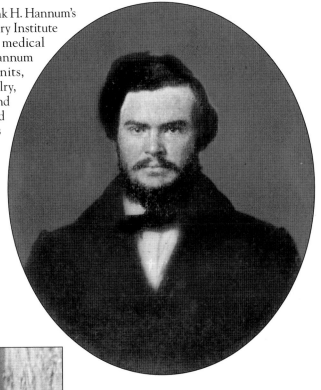

At the beginning of the Civil War, Swinfield Dillard Howell was a captain in the Jack's Creek, North Carolina, volunteer militia. In 1862, he joined the 58th North Carolina Infantry, and from that point, he fought in all the major battles of the Army of Tennessee. Swinfield moved to Unicoi around 1900 and was living with his son Samuel Peter on Riverside Avenue at his death in 1913. (Courtesy of Bob Howell.)

Gutheridge Garland served in the Union army during the Civil War as a private in the 13th Tennessee Volunteer Cavalry before transferring to the 3rd North Carolina Mounted Infantry, where he served as a lieutenant. A descendant of early Limestone Cove settlers, Gutheridge was part of the first Unicoi County Court, which was organized in 1876. (Courtesy of E. Harold Burleson.)

In 1863, Daniel Schultz enlisted in the Union army's 11th Regiment, Company K, Tennessee Volunteer Cavalry. Daniel was discharged from the 9th Cavalry, Company K, in 1865. Later he used medical knowledge he learned while working with Civil War physicians to treat his grateful neighbors in Limestone Cove. In the last year of his life, 1919, "Dr. Schultz," as his patients called him, was still delivering babies. (Courtesy of Hattie Bell.)

In 2007, John Vinton White sits on the steps of his grandfather Solomon White's old house on Pinnacle Road, recalling his boyhood days spent alternating between living with his grandparents in Unicoi and living with his father, John Clifford White, in Washington, D.C. John Vinton served with the U.S. Army in Europe during the Korean Conflict. His grandfather Solomon was a soldier in the Spanish-American War. John Vinton's great-grandfather John Christopher White and his great-great-grandfather Abraham White fought for the Union during the Civil War. Below, in the third row, Abraham is third from left and John Christopher is fourth from left in this group photograph of Unicoi County Civil War veterans taken in the early 1900s. (Above courtesy of John Vinton White; below, courtesy of Chuck McInturff.)

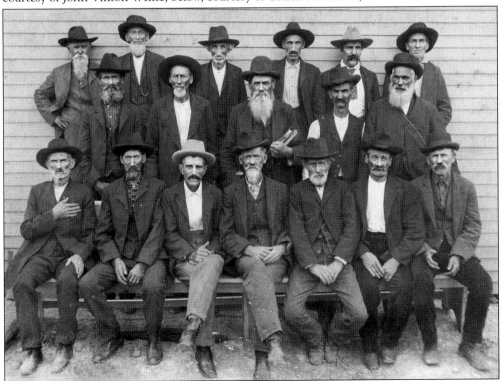

Pictured here, Shep McInturff is wearing his Spanish-American War uniform. Shep served as a cook for his regiment. His children recall that while they were growing up, he made donuts from a recipe he used while cooking for the soldiers. (Courtesy of Jack Jones.)

Paul White (right) served as a military policeman for the U.S. Marine Corps in Haiti from 1931 to 1935. Later, during World War II, White served with the U.S. Army and fought in the Battle of the Bulge. For his distinguished service in Europe, Sergeant White received a Purple Heart, Good Conduct Medal, Distinguished Unit Citation, and three Bronze Stars. White was the Unicoi County court clerk for 28 years and the sheriff for 8 years. (Courtesy of Chuck McInturff.)

In 1942, John Marcus was inducted into the U.S. Army Signal Corps and was sent to England. There, amidst the trying times of World War II, John found new life and love when he met Marjorie Nash, his future wife. One year after their marriage, he and Marjorie became the parents of Richard, the baby John lovingly holds in his arms in this picture. (Courtesy of John Marcus.)

Born in Great Britain, Marjorie Nash met Pvt. John Marcus at a USO club in Salisbury, England, in 1943, and married him on June 5, 1944. Through the years, local and regional newspapers and magazines featured stories about the beautiful girl that left her native England to make a home in Limestone Cove. Marjorie and John had two children, Richard and Donna, and were married 61 years before Marjorie's passing in 2005. (Courtesy of John Marcus.)

Schoolteacher Alma Sutphin's fiancé, Roy Cates, was a soldier in the U.S. Army during World War II. Alma missed him very much and carried a large picture of him around to look at when she felt especially lonesome. Roy and Alma married in 1945 after he returned. Both had distinguished careers as educators. (Courtesy of Alma Cates.)

Roy Cates was stationed in Alaska and the Aleutian Islands during World War II. Pictured here while on leave, Cates and his fiancée, Alma Sutphin, stand beside Street's Store in Unicoi. (Courtesy of Alma Cates.)

Born in Unicoi, flight engineer Eugene Adkins manned the upper turret of the famed World War II bomber the *Memphis Belle*. After the B-17 successfully completed 25 missions over Nazi-occupied Europe during 1943 and 1944, its entire crew returned home to a hero's welcome. Eugene was one of the crew consulted for the popular 1990 feature film *Memphis Belle*. (Courtesy of Howard Street.)

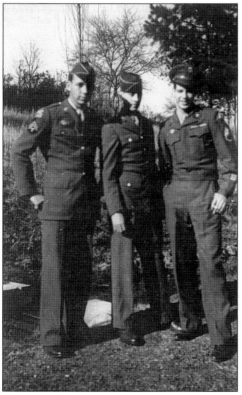

Mallie and Mae Wilson had three sons serving in the U.S. Army during World War II. Walter (left) fought in the Pacific, and Charles (right) fought in Europe. Paul (center) entered World War II not long before it ended and did not have to go overseas. (Courtesy of Steve Wilson.)

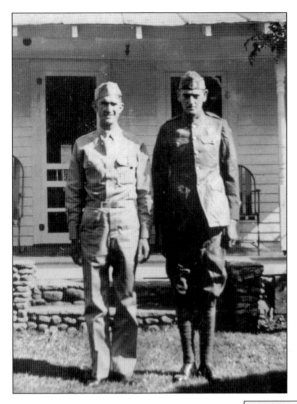

Pictured in 1946, Sgt. Jay Hopson (left) and neighbor Chester Jones compare uniforms. Notice the difference between Hopson's World War II khakis and Chester's World War I uniform with its long jacket and leggings. Hopson served in Europe. (Courtesy of Terry Hopson.)

Brothers Earl (left) and Ross Hopson served in the U.S. Army during World War II. Though Earl was a minister, rather than serve as a chaplain, he fought with the 79th Infantry in Europe because he feared the army would tell him what to preach. He explained, "the government didn't call me to preach. God called me to preach." Hopson served as a medic in Egypt, the South Pacific, and Europe (including the Normandy invasion), and was captured twice by the Germans. Though he survived the war, Hopson was killed in an auto accident in 1963 after returning home to Unicoi. He is remembered for his likeable personality and for his talents as an athlete. (Courtesy of Speedy Hopson.)

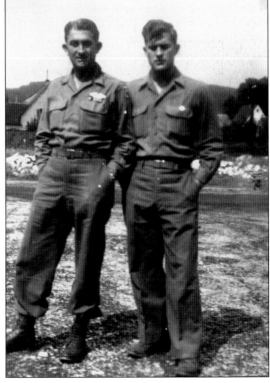

Howard C. Linville served with the U.S. Navy in the Solomon Islands during World War II. After the war ended, he returned to Unicoi and married Ruth Leedy. H. C. was a machinist for the Clinchfield Railroad during its steam-engine days, and later he became a diesel electrician. H. C. and Ruth's son Carl served with the navy during the Vietnam War. (Courtesy of James Linville.)

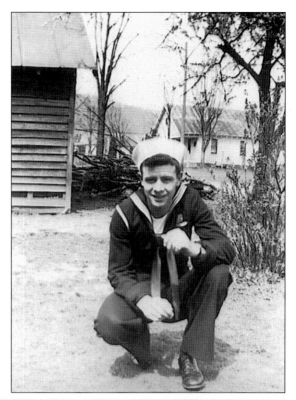

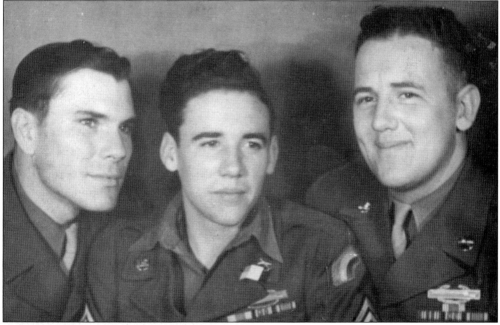

Shown here between two of his army buddies, Sgt. Nathan Woodby served in the Europe during World War II. In 1945, he was with the Allied forces that liberated the Dachau concentration camp in Germany. Nathan married Lucy Tolley. Their children are Dianna, Kenneth, and Teresa. (Courtesy of Nathan Woodby.)

S2c. Marion Linville served in the U.S. Navy during World War II. He worked for Koppers Company in Baltimore, Maryland, for 39 years, including time both before and after the war. Linville and his first wife, Marie Peterson, had three children: Dennis, Linda, and Joe. In 1974, Linville married Daphne Bellamy, and they lived in Unicoi County until his death in 1997. (Courtesy of Daphne Linville.)

Robert Linville served with the U.S. Army in Europe. While still in the army, he married Helen Leedy. They had two children, Patsy and Gordon. (Courtesy of James Linville.)

Pictured around 1947, Alvin Garland is back home in Unicoi after serving in the U.S. Army during World War II. In 1944, Sergeant Garland stood on Mindanao Island in the Pacific and watched as Gen. Douglas MacArthur waded ashore in his famous return to the Philippines. "MacArthur said he'd return," Alvin says, "and we returned him." (Courtesy of Alvin Garland.)

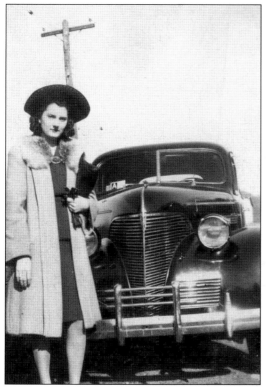

Wartime sweethearts Ruby Harrell and Alvin Garland wrote letters to one another almost every day while Alvin was in the army during World War II. Ruby stands beside her first car, a shiny new 1947 Chevy bought with money she saved from working at Southern Potteries in Erwin. (Courtesy of Ruby Garland.)

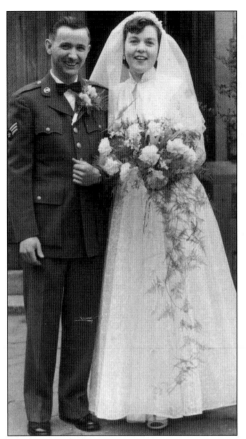

Ralph Garland met Joan Baxter, the woman he has been married to for 55 years, while serving in the U.S. Air Force in England in the 1950s. Here Ralph and Joan are saying their wedding vows in Harrow, Middlesex, England, in 1954. Ralph and Joan have one daughter, Michelle Garland Browning. (Courtesy of Ruby Garland.)

T.Sgt. Phil Hawkins married Edith Tinker in 1944 while serving in the U.S. Army's 250th Signal Operations Company during World War II. He and Edith are pictured in 1941. Hawkins entered the army the following year. (Courtesy of Edith Hawkins.)

Jack Snider served in the U.S. Army during World War II. Here he is home on leave, smiling and surrounded by old friends in Unicoi. From left to right are (first row) Bessie Sneyd, George Street, and Hazel McInturff; (second row) Jack Hawkins, Gladys Garland, Jack Snider, and Terry Hopson. Snider received three bronze battle stars while serving in Europe. (Courtesy of Jack Snider.)

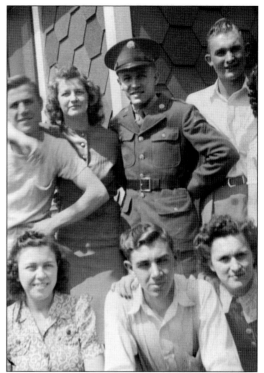

In 1945, Hazel McInturff (center) and two friends pretend to hitch a ride in Cleveland, Ohio, where they served as WAVES (Women Accepted for Volunteer Emergency Service) during World War II. McInturff trained in Bronx, New York, and worked as a storekeeper during her time in Cleveland. In 2009, McInturff had worked 45 years as a volunteer at the Mountain Home Veterans' Hospital in Johnson City, Tennessee. (Courtesy of Hazel Berry.)

With World War II behind them, sweethearts Hazel McInturff and Richard Berry stand beside Hazel's home looking forward to marriage and a life together. Richard served aboard the USS *Prairie* in the Pacific theater while Hazel served with the WAVES in Cleveland, Ohio. (Courtesy of Hazel Berry.)

Alexandra Shew (left) and her brother Nicholas delight in modeling the navy uniforms worn by their grandfather Richard Berry and grandmother Hazel Berry while serving their country in World War II. Hazel and Richard's daughters are Karen Sue and Dianne Lynn, the mother of Alexandra and Nicholas. (Courtesy of Hazel Berry.)

During World War II, while serving aboard the USS *McCoy Reynolds*, a navy destroyer escort operating in the Caribbean and South Pacific, Jack Hawkins earned four battle stars. His ship sank two Japanese submarines. In 1945, Hawkins was aboard the *McCoy Reynolds* when it passed through the eye of a typhoon. After the war, he married Margie Hatcher. (Courtesy of Terry Hopson.)

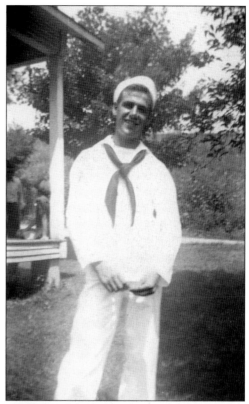

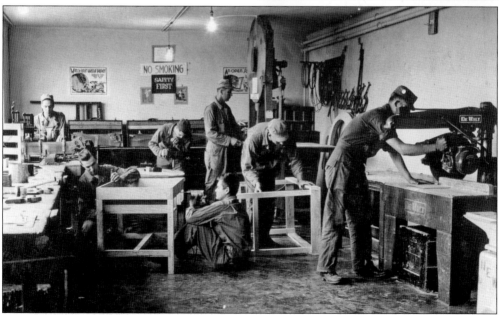

During World War II, Terry Hopson served in the U.S. Army Air Corps as a drill instructor. Pictured here in England at the war's end, Hopson (far right) works the cut-off saw, helping his fellow servicemen construct waterproof containers for shipping military equipment back home. (Courtesy of Terry Hopson.)

Pictured before World War II began, Carson Simerly is enjoying an outing with his wife, Lena, and their infant son, Rex. Carson served with the U.S. Army in the Philippines. Carson and Lena's other sons are Steve and Max. (Courtesy of Max Simerly.)

It is 1945, and young World War II soldier Pleasey Sneyd is back home in Limestone Cove with his wife, Bertha. Pleasey entered the U.S. Army on January 5, 1942, shortly after his marriage to Bertha, and went on to serve in England, Belgium, and Germany. (Courtesy of Geraldine Love.)

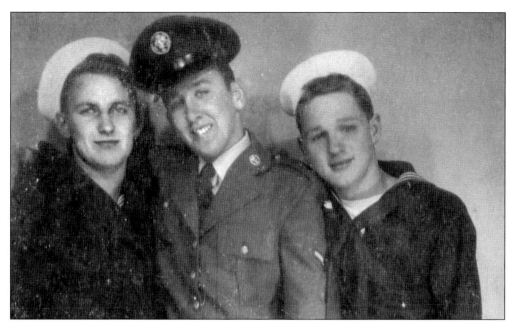

Though this picture from 1955 has seen some wear and tear, it still shows the friendship and affection between these young men from Unicoi as they reunite after completing boot camp. From left to right are Don Wilson, Opie Blevins, and Tom Britt. Don and Tom served on the same ship in the U.S. Navy, and Opie served in the U.S. Air Force. (Courtesy of Don Wilson.)

Here Air Corpsman Speedy Hopson is playing shortstop for the Ladd Flyers at Ladd Air Force Base in Fairbanks, Alaska, where he was stationed in the 1950s. After Speedy returned home, major-league recruiters approached him about trying out for their teams, but he chose to stay in Unicoi and raise a family with his wife, Harriett. (Courtesy of Speedy Hopson.)

Harry Britt met Shirley Thayer in 1955 while stationed with the U.S. Navy's VP-26 patrol squadron in Brunswick, Maine. In 1958, Britt moved his new bride to Unicoi. Harry worked for Nuclear Fuel Services for 35 years. He was a supervisor, scheduler, and production and maintenance foreman. Britt also served as a Unicoi County commissioner. Harry and Shirley's children are Donald, Donna, and Phillip. (Courtesy of Harry Britt.)

While serving in the U.S. Navy, Harry Britt spent more time in airplanes than in ships and survived a crash in a Lockheed P-2V5F Neptune in 1957. Britt was a crew chief and 2nd class aviation machinist mate. Pictured with one of his flight crews, Harry is second from right in the first row. (Courtesy of Harry Britt.)

William L. "Billy Lee" Wilson joined the U.S. Marine Corps Reserves in 1951 and trained at Parris Island, South Carolina. After 18 months of active duty with the marines, Sergeant Wilson entered East Tennessee State University, and in 1957, he received a bachelor's degree and was admitted to the U.S. Navy's Officer Candidate School. He was a naval commander when he retired from the navy reserves in the late 1970s. (Courtesy of Billy Lee Wilson.)

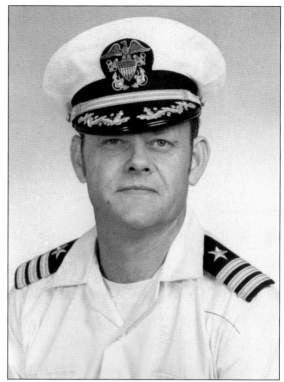

All six of Jake and Hassie Hopson's sons served in the military. However, Johnny (standing second from left) was the only one who fought in Korea. He served with the famed 2nd Marine Division during the grueling winter evacuation from the reservoir region near the Communist border. (Courtesy of Speedy Hopson.)

Sgt. Howard Street served with the 70th Tank Battalion, a support group for the 1st Cavalry Division of the U.S. Army, during the Korean Conflict in the early 1950s. Though involved in a terrible tank explosion, the young sergeant survived, and while recuperating in a hospital in Tokyo, Japan, he met his future wife, Fumiko Saito. (Courtesy of Howard Street.)

Family and friends gave Howard Street's Japanese war bride Fumiko Saito the name "Who." A smiling Howard sits beside Who in 1965 as they gather with his father, Monroe Street; sisters Thelma White and Hazel Brooks; brother Phil Street; and brother-in-law Claude White. Howard and Who's daughter Lisa looks on. (Courtesy of Howard Street.)

Entering the U.S. Army at the peak of World War II, Col. Talmadge F. McNabb served as a chaplain for most of his 25 years of military service. While in Germany, he was senior chaplain for the largest military hospital in Europe. In Korea, he rescued a "GI baby" from possible death, and as a result, an Oregon couple adopted the little girl and founded an international adoption service that served many GI babies. (Courtesy of Harry Britt.)

Fred Gouge earned a Purple Heart while serving in the Vietnam War. As the cross around his neck indicates, his faith was very important to him. While in Vietnam, he suffered an injury that left him in a wheelchair, but this did not stop him from being an active member of Pathway Freewill Baptist Church for many years. Fred and his wife, Linda, had been married 34 years at the time of his death in 2007. (Courtesy of Robert Gouge.)

www.arcadiapublishing.com

Discover books about the town where you grew up, the cities where your friends and families live, the town where your parents met, or even that retirement spot you've been dreaming about. Our Web site provides history lovers with exclusive deals, advanced notification about new titles, e-mail alerts of author events, and much more.

MADE IN THE

Arcadia Publishing, the leading local history publisher in the United States, is committed to making history accessible and meaningful through publishing books that celebrate and preserve the heritage of America's people and places. Consistent with our mission to preserve history on a local level, this book was printed in South Carolina on American-made paper and manufactured entirely in the United States.

This book carries the accredited Forest Stewardship Council (FSC) label and is printed on 100 percent FSC-certified paper. Products carrying the FSC label are independently certified to assure consumers that they come from forests that are managed to meet the social, economic, and ecological needs of present and future generations.

FSC
Mixed Sources
Product group from well-managed forests and other controlled sources

Cert no. SW-COC-001530
www.fsc.org
© 1996 Forest Stewardship Council

Find Your Place in History.